Colored Pencil
Drawings & Doodles

Draw Adorable Animals, Flowers, Foods and Characters with Just 12 Colored Pencils!

Atelier RiLi

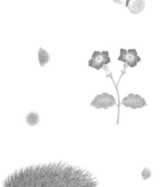

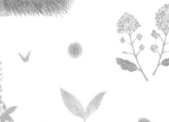

TUTTLE Publishing

Tokyo | Rutland, Vermont | Singapore

Contents

Introduction 4
How to Use This Book and Watch the Video Lessons 10

CHAPTER 1 The Basics 11
Preparing the Tools 12
The Fundamentals of Colored Pencils—Part 1 14
How to Trace a Preliminary Sketch 16
The Fundamentals of Colored Pencils—Part 2 18
Various Coloring Techniques 20
Making a Color Chart 22

CHAPTER 2 Small Motifs 23
Delicate Flowers and Plants
 Lesson 1 Tulips 24
 Lesson 2 Roses 26
 Lesson 3 Clover 28
Try Drawing Various Flowers and Plants 30
Miscellaneous Items and Foods
 Lesson 4 Ribbons 36
 Lesson 5 Cupcakes 38
 Lesson 6 French Bread 40
Try Drawing Various Items and Foods 42
Drawing Sweet & Simple Monochromatic Illustrations 46

CHAPTER 3 Detailed Motifs 47
Fairytale-like Buildings
 Lesson 7 Cottages with Colorful Roofs 48
 Lesson 8 Castles and Towers with Spires 50
Try Drawing a Fairytale-like Town 52
Small Birds and Forest Animals
 Lesson 9 Flycatchers 54
 Lesson 10 A Cat 56
 Lesson 11 A Hedgehog 58
Try Drawing Birds and Forest Animals 60
Landscapes with Children
 Lesson 12 A Girl Picking Flowers 66
 Lesson 13 A Boy Reading a Book 68
Try Drawing the Composition "Gnomes and Children in the Forest" 70
Background Illustrations Drawn with Simple Lines 72

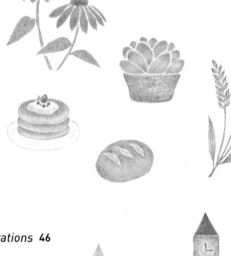
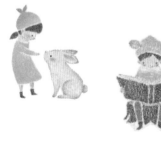

CHAPTER 4 *Seasonal Motifs* **73**

The Pastel Shades of Spring
 Lesson 14 Strawberries **74**
Try Drawing the Colors of Spring **76**
The Vivid Colors of Summer
 Lesson 15 Goldfish **80**
Try Drawing the Colors of Summer **82**
The Warm Colors of Autumn
 Lesson 16 Mushrooms **86**
Try Drawing the Colors of Autumn **88**
The Cool Jewel Tones of Winter
 Lesson 17 A Snowman **92**
Try Drawing the Colors of Winter **94**
Color the Seasons with Spot Illustrations **98**

CHAPTER 5 *Combining Elements* **99**

Draw Combinations of Flowers and Plants
 Lesson 18 Flowers and Ivy **100**
 Lesson 19 A Small Bouquet **102**
Try Drawing Compositions Filled with Flowers **104**
Color a Picture-book-like Scene
 Lesson 20 Illustrations with the Ground Included **106**
 Lesson 21 Illustrations with a Background **108**
Try Drawing a Picture-book-like Scene **110**
Level-up Your Toolkit **114**

CHAPTER 6 *Original Illustrations and Crafts* **115**

Draw Your Own Unique Illustrations **116**
Colored Pencil Craft Ideas to Color Daily Life **118**
How to Write Cute Letters **124**

Thank you for picking up this book!

Even with just a basic set of 12 pencils, if you blend colors
with awareness and care, an exciting new range of shades is born.

The joy of the moment when you feel you've drawn well, or when you
encounter an unexpected color, is something only the artist can understand.

The completed work, which persists after the ephemeral joys of its creation
have faded, imparts a new sense of wonder for those who see it.

As you gain experience with drawing, don't feel obligated to follow the exact
drawing sequences introduced in these pages. Freely explore your own way of
drawing, and try various methods to discover the techniques that suit you best.

Once you master these techniques, even if you draw similar motifs on different
occasions, you will never draw them exactly the same way twice, and your
creative process will remain fresh and rewarding.

My hope is that you will develop a profound familiarity with colored
pencils, learn how to create the various effects that suit
your artistic sensibilities and create your own
brilliant original drawings.

—Atelier RiLi

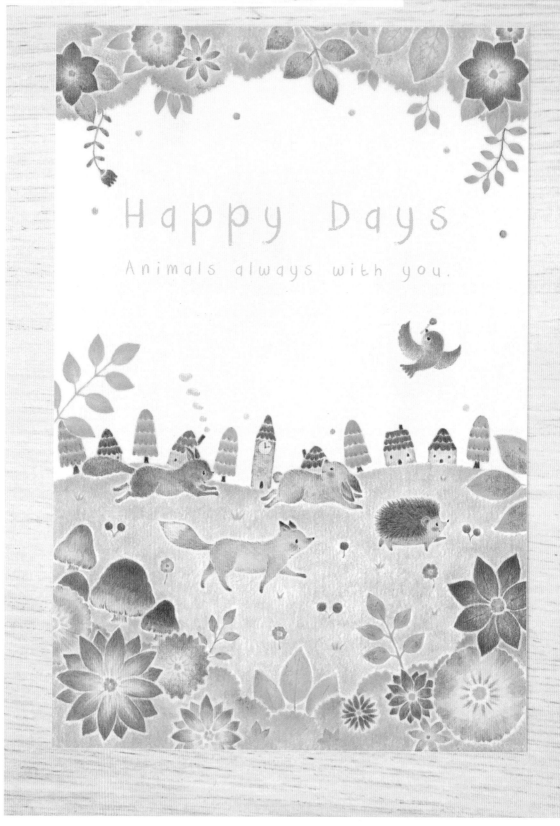

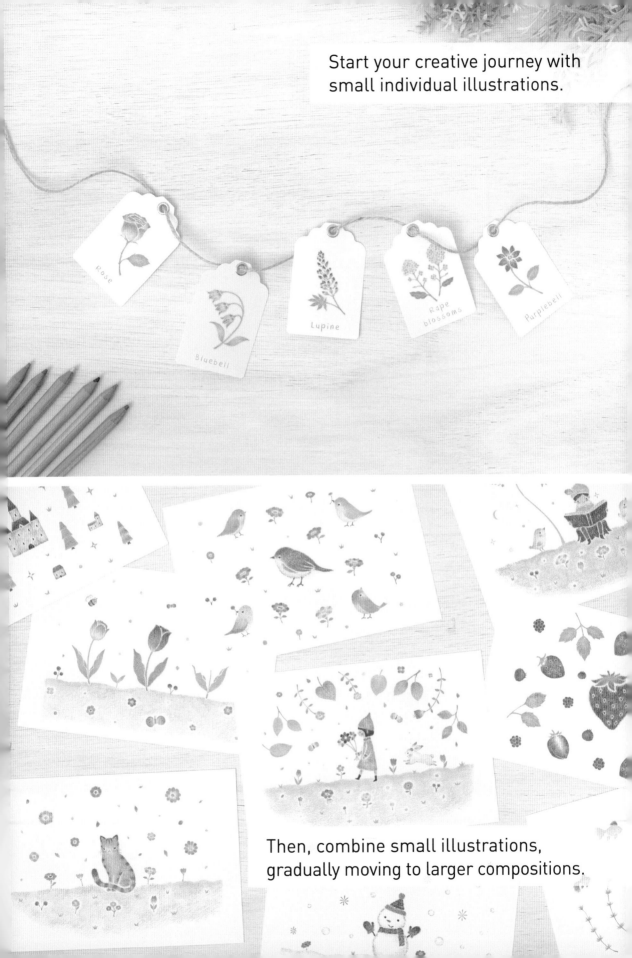

Start your creative journey with small individual illustrations.

Rose

Bluebell

Lupine

Rape blossoms

Purplebell

Then, combine small illustrations, gradually moving to larger compositions.

Add lettering with colored pencils to make festive handmade cards.

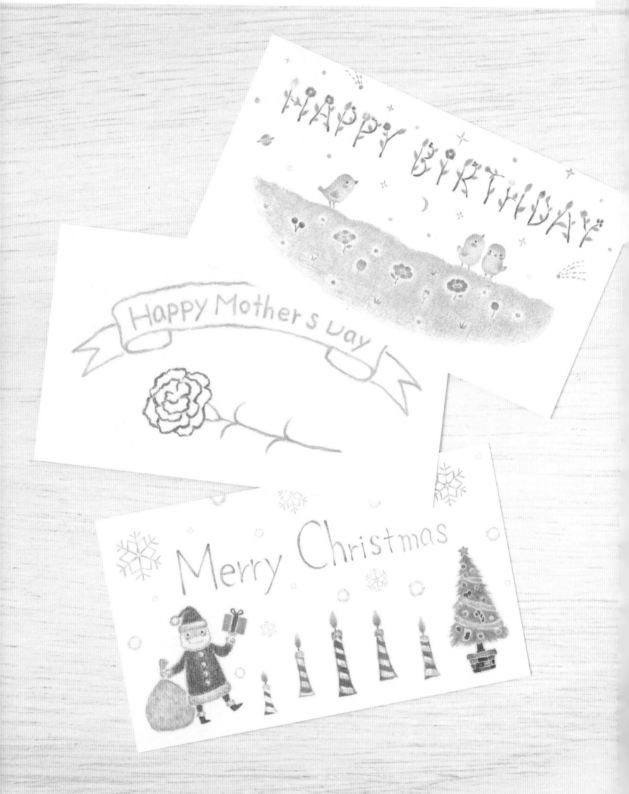

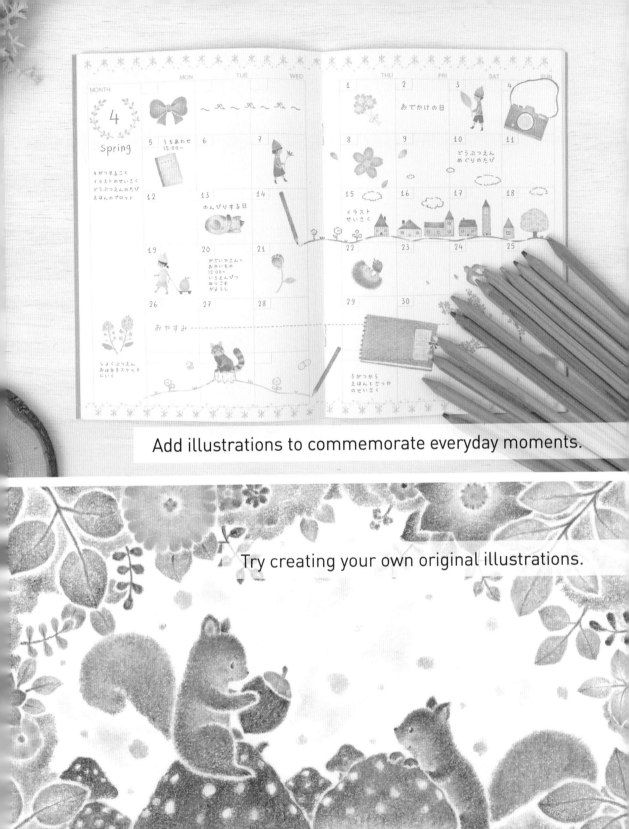

Add illustrations to commemorate everyday moments.

Try creating your own original illustrations.

How to Use This Book

This book offers lessons on how to draw with colored pencils, providing 21 basic motifs. Each lesson has drawing instructions both in print and through videos. Begin each lesson by copying the preliminary sketch.

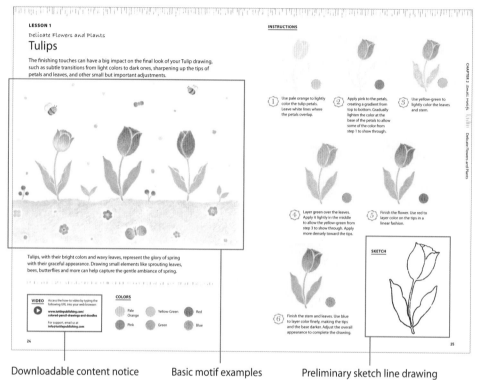

Downloadable content notice Basic motif examples Preliminary sketch line drawing
(see download instructions on page 17)

HOW TO VIEW THE VIDEO LESSONS

How to access the how-to videos and printable PDFs

1. Make sure you have an Internet connection.
2. Type the URL below into your web browser.

www.tuttlepublishing.com/colored-pencil-drawings-and-doodles

For support, you can email us at **info@tuttlepublishing.com**

CHAPTER 1

The Basics

Before starting to draw illustrations, it's essential to prepare the tools and understand their basic usage. In section 2 of this chapter (starting on page 18), I'll show you how to draw basic motifs based on preliminary sketches. You'll also learn how to transfer these sketches onto paper and about colored pencil coloring techniques and creating a color chart.

Preparing the Tools

The fundamental tools required are colored pencils and white paper. You don't necessarily need to purchase any special tools. Start by using what you have on hand.

Colored Pencils

A basic set of 12 oil-based colored pencils. In this book, I use ones from MUJI. If you already have colored pencils, feel free to use them.

Paper (Sketchbook)

It's easier to draw if you detach the paper from the sketchbook. Paper for sketching has a front and a back, with the cover-facing side being the front. For colored pencil drawings, a paper surface that isn't too rough or too smooth is ideal.

Products Used in This Book

MUJI Colored Pencils 12-color set

Characterized by its unpainted wooden shaft, this MUJI colored pencil set is affordable at under US$15.

MUJI Sketchbook Postcard Size

This sketchbook has perforated lines, making it easy to detach postcard-sized sheets. Priced at about US$15.

Graphite Pencil

Used for preliminary sketches and drawing details like facial expressions. Softer leads like 2B or B are recommended as they are easy to erase and leave fewer marks on the paper.

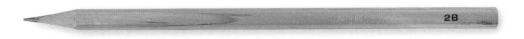

Plastic Eraser

A standard eraser with sharp edges is preferred for erasing small details.

Pencil Sharpener

A manual sharpener is better than an electric one as it allows you to precisely adjust the sharpness of the pencil with little waste.

Blotting Sheet

Helpful for preventing smudging by your hands as you move about the drawing while you work. In the video lessons, thick paper is used.

Test Paper

When layering colors, the lead of your colored pencil can pick up traces of different colors, which can then mix and discolor your drawing. It's convenient to have test paper on hand to clean the pencil tip, check sharpness or for quick blending tests.

+ Tools FAQ + + + + + + + + + + + + + + + + + +

Q Do I need expensive colored pencils from art stores?

A You don't necessarily need expensive colored pencils. Start with the ones you have, and once you're accustomed, you can try more professional-grade pencils. (Refer to page 114.)

Q Do I need the exact same colors as those in the book?

A This book uses a basic set of 12 colors. If you have similar shades, you should be able to draw as directed. Because color shades vary by manufacturer, create a color chart and test the colors before drawing. (Refer to page 22.)

+ +

The Fundamentals of Colored Pencils—Part 1

Let's go over the preparation and basic usage of colored pencils before drawing with them.

 ## Sharpening Colored Pencils

The sharpness of colored pencils should be adjusted depending on your drawing technique. Avoid sharpening them too long and overextending the length of the tip.

Using New Colored Pencils

Basic Sharpening Technique

Drawing Fine Details

Even if colored pencils are pre-sharpened, it's a good idea to sharpen them a bit before starting to use them.

Having a slightly rounded tip makes it easier to apply color evenly with moderate pressure and reduces visible strokes.

When drawing fine lines or small areas, it's easier to draw with a sharper tip.

 ## Using an Eraser

Colored pencils are not as easy to erase cleanly as regular graphite pencils. Erasers are used for erasing the underdrawing and as a technique in drawing.

Creating Depth

When you want to create a sense of depth, gently use an eraser on the brightly lit areas of your subject. This will remove some color and enhance the three-dimensional effect. Use a clean edge of the eraser.

Erasing the Underdrawing

If the lines from the underdrawing remain dark, coloring over them will make it difficult to remove traces of them later, particularly with lighter colors, resulting in a messy final look.

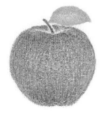

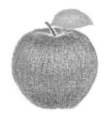

Before Using an Eraser

After Using an Eraser

Clean Example

Example with Pencil Marks

🌱 Grip on the Pencil

Basic Grip

This is the usual way to hold a pencil. Apply lighter pressure than when writing and gently stroke the paper.

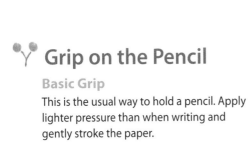

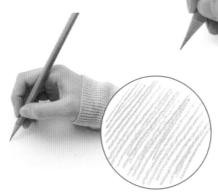

Flat Grip

This grip is suitable for covering larger areas evenly. Ensure even pressure without pressing too hard.

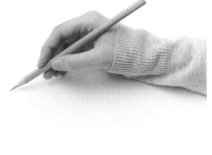

Upright Grip

This grip involves slightly more pressure than the basic grip and is used when you want to draw thin lines or accentuate details.

How to Trace a Preliminary Sketch

In this book, underdrawings are included to use as references.
Here, I introduce the method of tracing (copying) the underdrawing.

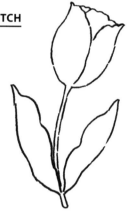

SKETCH

MATERIALS NEEDED

- **Pencils of 2B hardness or greater: Darker pencils are easier to trace with.**
- **Tracing paper (Tracing paper can be very thin, or even regular thin paper.)**
- **Drawing paper: What you will use for finishing the illustration with colored pencils.**
- **Masking tape: Used to hold the tracing paper in place during tracing.**

STEPS

 Prepare the underdrawing, and then place the tracing paper on top of it.

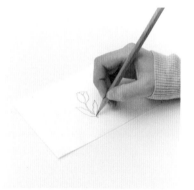

 Trace the underdrawing with a pencil.

VIDEO

Access the how-to video by typing the following URL into your web browser:

www.tuttlepublishing.com/ colored-pencil-drawings- and-doodles

For support, email us at **info@tuttlepublishing.com**

 Flip the tracing paper over and, with the pencil tip lying flat, firmly shade over the lines of the underdrawing to apply a layer of graphite.

 Place the tracing paper on the drawing paper with the traced lines facing up, and secure it with masking tape.

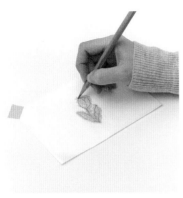
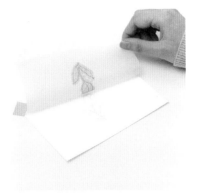

 ⑤ Trace over the lines with a pencil, being gentle to avoid leaving pencil depressions on the drawing paper.

⑥ Remove the tracing paper, and you're done.

ADDITIONAL TIPS

- In the book's instructions, the underdrawing is depicted with a darker line for better visibility, but when actually creating your artwork, it is recommended to use the lightest lines that you can see.
- Be mindful of the pressure applied to avoid indenting the drawing paper, and practice a few times to learn control.
- Instead of tracing with tracing paper, you can also use the underdrawing as a rough guide and add freehand details on your own. This method is useful for depicting small and intricate parts.

Download the Underdrawings

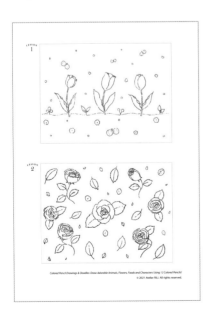

The underdrawings of the motifs featured in this book can be downloaded as PDF files. PDFs can be printed multiple times, saving you time when tracing, and allowing you to adjust the size during printing. Refer to the instructions below.

DOWNLOAD

Access the printable PDFs by typing the following URL into your web browser:

www.tuttlepublishing.com/colored-pencil-drawings-and-doodles

For support, email us at **info@tuttlepublishing.com**

The Fundamentals of Colored Pencils—Part 2

Now, let's finally start using colored pencils! The illustrations in this book are drawn without outlines, so we'll be using colored pencils to fill in areas while carefully adding details.

Basic Coloring Technique

Gently apply colored pencil to the paper, using just enough pressure to leave a slightly textured layer of color on the paper. Even if a single color appears light, layering multiple colors creates depth in the hue and produces beautiful gradients. It's better to apply color gradually, avoiding filling everything in one pass, which makes it easier to correct mistakes.

ILLUSTRATION 1 **Intensity of Coloring**

✓ This is the right level of intensity where colors can be easily layered on top, and erasing with an eraser is also effective.

✗ Due to applying one color too heavily, it's difficult to layer more colors on top, and erasing leaves visible marks.

ILLUSTRATION 2 **Order of Layering Colors**

✓ ● Pink → ● Red
Starting with a lighter color allows the colors to blend nicely.

✗ ● Red → ● Pink
Layering a lighter color on top of a darker one can make the blend less noticeable.

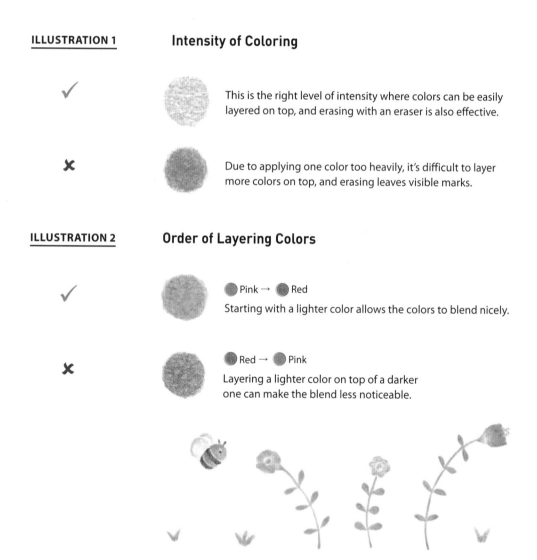

ILLUSTRATION 3 Pencil Orientation

Creating Flow in Coloring

Being mindful of the direction of fibers or lines while using colored pencils. Lining up strokes can change the texture and appearance of the drawing.

Uniform Coloring

Not focusing on the orientation of strokes results in a uniform and flat illustration.

Creating Softness in Coloring

Circling and swirling while coloring can create a soft and gentle appearance.

ILLUSTRATION 4 Applying Color Progressively and Uniformly

To achieve the desired intensity, don't try to complete it in a single stroke. Layer the colors multiple times, starting lightly, and continue with a similar level of pressure to avoid unevenness.

Various Coloring Techniques

Here, I'll introduce various ways to apply colors with different intensities. In this book, illustrations are created using only 12 colored pencils, but by layering colors, you can achieve a wide range of hues.

 ## Layering Colors

Layering different colors creates new shades and adds depth to your artwork. Try experimenting with 2–3 colors as a guideline.

1. Apply yellow evenly across the entire area.
2. Layer yellow-green on top.
3. Add a light layer of light blue.
4. Once more, lightly layer yellow to blend the colors throughout.

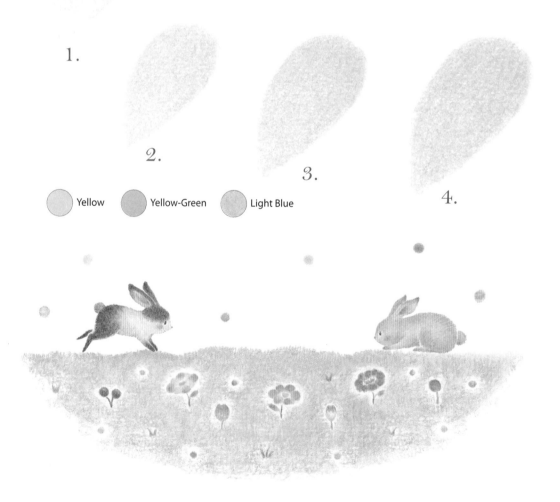

1.

2.

3.

4.

Yellow Yellow-Green Light Blue

Creating Gradients

Start by applying a light layer across the entire area, then gradually layer more color where you want it to be darker. As you become more comfortable, try going from dark to light while easing off the pressure.

1. Apply an even layer across the entire area.
2. Layer lightly over about half of the petal.
3. Layer over approximately one-third of the petal.
4. Darken the tip of the petal.

1.

2.

3.

4.

 Orange

Preserving the White of the Paper, Emphasizing Contours

To represent white in an illustration on white paper, preserve the white of the paper. Gently and lightly outline the contours without coloring the areas you want to appear white.

1. Use light blue to gently outline the overall contours, depositing small patches color.
2. Layer on pink in some areas.
3. Similarly, layer on blue like you did with the pink.
4. Layer on more light blue and apply a very light layer on the inside.

1.

2.

3.

4.

 Light Blue Pink Blue

Making a Color Chart

When you're using colored pencils for the first time, it's a good idea to create a color chart. This will help you get to know your own coloring style and how each colored pencil performs.

Creating a Color Chart

Even within the same set of colored pencils, you may notice variations in how each color appears on paper. By repeatedly doing test strokes as shown in the table below, you can familiarize yourself with the characteristics of your colored pencils.

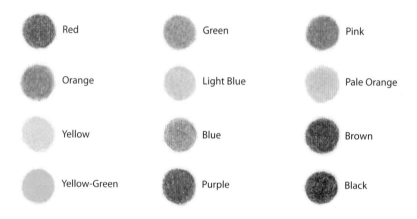

Red

Green

Pink

Orange

Light Blue

Pale Orange

Yellow

Blue

Brown

Yellow-Green

Purple

Black

2-Color Blend Samples

Colors become more complex and darker as they are mixed. The order in which you apply colors can also affect the resulting hue. Experiment and discover new color blends.

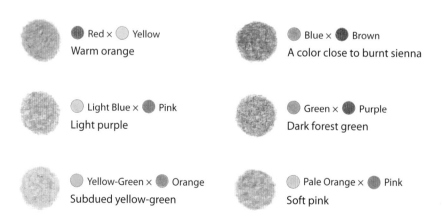

Red × Yellow
Warm orange

Blue × Brown
A color close to burnt sienna

Light Blue × Pink
Light purple

Green × Purple
Dark forest green

Yellow-Green × Orange
Subdued yellow-green

Pale Orange × Pink
Soft pink

CHAPTER 2

Small Motifs

In the introductory lessons, you will start by drawing
plants like tulips and clover. Begin with simple motifs and
gradually progress. Next, in lessons featuring everyday
small objects like ribbons and cupcakes, you will
primarily learn about layering colors.

Delicate Flowers and Plants

Tulips

The finishing touches can have a big impact on the final look of your Tulip drawing, such as subtle transitions from light colors to dark ones, sharpening up the tips of petals and leaves, and other small but important adjustments.

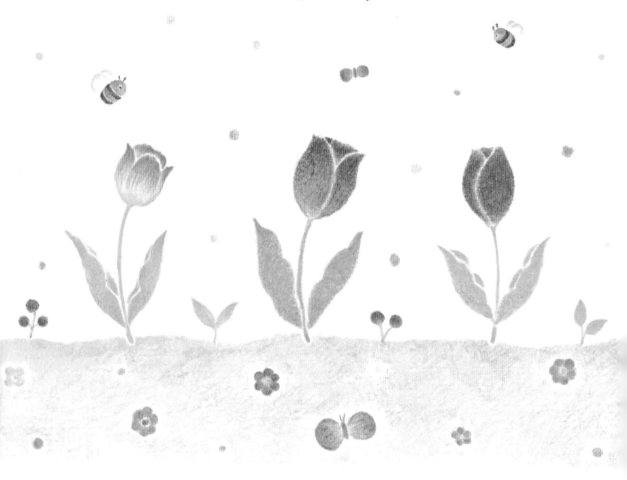

Tulips, with their bright colors and wavy leaves, represent the glory of spring with their graceful appearance. Drawing small elements like sprouting leaves, bees, butterflies and more can help capture the gentle ambiance of spring.

VIDEO Access the how-to video by typing the following URL into your web browser:

▶ www.tuttlepublishing.com/
colored-pencil-drawings-and-doodles

For support, email us at
info@tuttlepublishing.com

COLORS

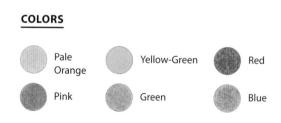

- Pale Orange
- Yellow-Green
- Red
- Pink
- Green
- Blue

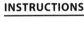

INSTRUCTIONS

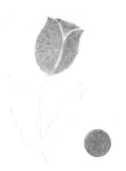
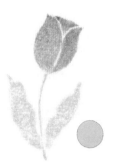

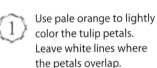

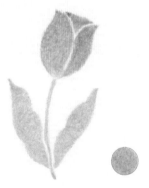
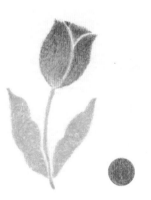

① Use pale orange to lightly color the tulip petals. Leave white lines where the petals overlap.

② Apply pink to the petals, creating a gradient from top to bottom. Gradually lighten the color at the base of the petals to allow some of the color from step 1 to show through.

③ Use yellow-green to lightly color the leaves and stem.

④ Layer green over the leaves. Apply it lightly in the middle to allow the yellow-green from step 3 to show through. Apply more densely toward the tips.

⑤ Finish the flower. Use red to layer color on the tips in a linear fashion.

SKETCH

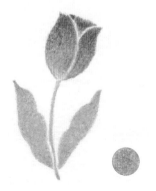
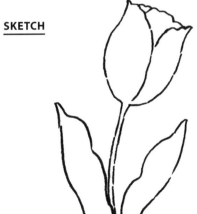

⑥ Finish the stem and leaves. Use blue to layer color finely, making the tips and the base darker. Adjust the overall appearance to complete the drawing.

Delicate Flowers and Plants

Roses

Create a soft appearance by leaving the spaces between finely-overlapping petals white without outlining them.

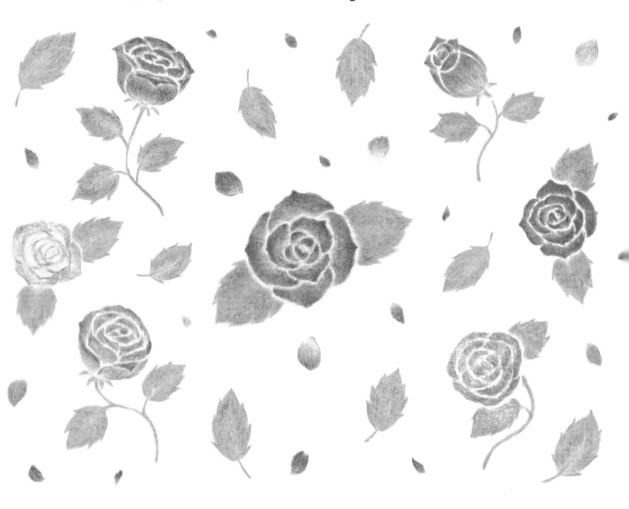

The rose, sometime referred to as the "queen of flowers," is not only admired for the beauty of the flower itself but also for the exquisite beauty of each velvety petal. Express these attributes by carefully layering colors.

VIDEO Access the how-to video by typing the following URL into your web browser:

www.tuttlepublishing.com/ colored-pencil-drawings-and-doodles

For support, email us at **info@tuttlepublishing.com**

COLORS

- Yellow
- Pink
- Green
- Orange
- Yellow-Green
- Red

INSTRUCTIONS

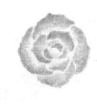
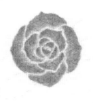

① Use yellow to lightly color the larger outer petals of the rose. Leave white lines at the edges of the underdrawing.

② Apply orange lightly to the outer parts of the petals.

③ Layer pink lightly on top of the color applied in steps 1 and 2.

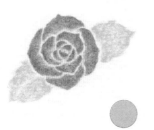
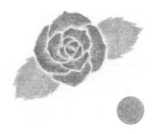

④ Use yellow-green to lightly color the leaves.

⑤ With green, apply a lighter layer to the center of the leaves and emphasize the edges of the leaves. Color the entire area.

⑥ Use red to darken the tips of the rose petals.

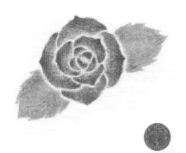

⑦ Layer red lightly on the tips of the leaves. Adjust the overall appearance to complete the drawing.

SKETCH

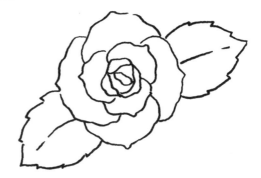

Delicate Flowers and Plants

Clover

By carefully layering the green of the leaves and leaving the white patterns untouched, the natural patterns emerge.

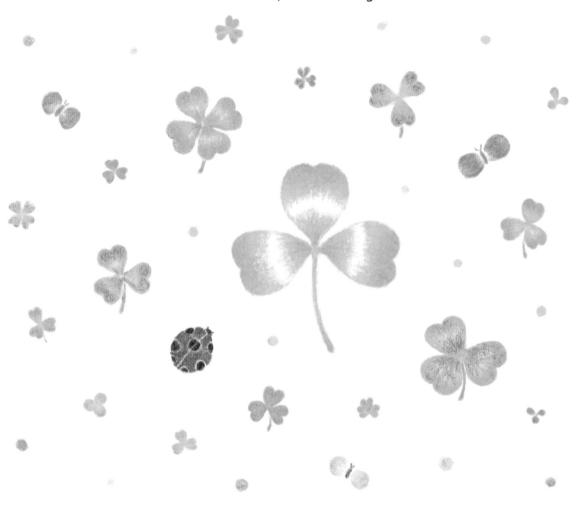

This is a clover with white markings on its leaves. Try drawing several with variations in shading and color. Adding a hidden four-leaf clover can be cute too.

VIDEO Access the how-to video by typing the following URL into your web browser:

www.tuttlepublishing.com/
colored-pencil-drawings-and-doodles

For support, email us at
info@tuttlepublishing.com

COLORS

○ Yellow ○ Light Blue

○ Yellow-Green ○ Green

INSTRUCTIONS

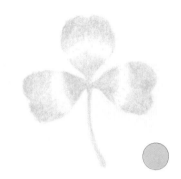

1 Apply yellow lightly. Avoid coloring the patterned parts, and gently draw the edges without creating distinct outlines.

2 Layer yellow-green over the color applied in step 1. Fill the stem in gradually, progressively adding color along the underdrawing instead of making long individual strokes.

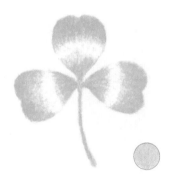

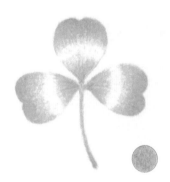

3 Layer light blue over the leaves and stem. Pay particular attention to the tips of the leaves and the central area.

4 Apply green to the tips of the leaves, the intersection of the leaves and the stem, and the stem itself.

SKETCH

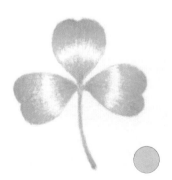

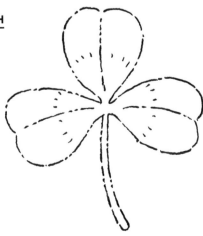

5 Lightly trace yellow-green along the outer edges of the pattern to outline it.

Try Drawing Various Flowers and Plants

FLOWER BLOSSOMS ONLY

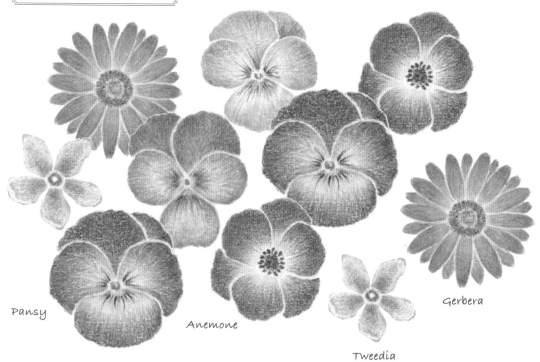

Pansy

Anemone

Tweedia

Gerbera

BEST TECHNIQUES

Pansy
The yellow parts of the petals have a firm outline when you incorporate pink and orange around them. The central pattern can be rendered with brown or purple. Draw the tips lightly and carefully.

Anemone
For the white central part, use a light touch and draw thin lines to preserve the white of the paper.

Gerbera
Lightly color the petals with pale orange, layering on yellow, pink and orange. Subtly add lines with pink or red to the tips.

Tweedia
Apply a light layer of pale orange across the entire flower, and then gradually layer on light blue and pink. The center should be darkened with subtle layers of blue.

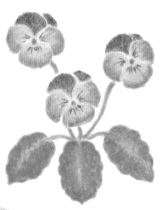

Sweet Pea

Bluebell

Freesia

Petunia

FLOWERS WITH LEAVES

BEST TECHNIQUES

Sweet Pea
To emphasize the softness of the petals, make them irregular in shape and avoid outlining them too strongly.

Bluebell
Start with a light application of light blue, and then lightly layer pink and yellow-green. Use fine lines to sharpen the tips of the petals.

Freesia
As it can be challenging to sharpen the tips with just yellow, layer on yellow-green and orange.

Petunia
Layer on a darker color at the tips of the petals to sharpen them.

Nemophila
Apply light blue and then layer on dark blue or purple.

Nemophila

Lupinus

Delphinium

Lupinus
For the flower cluster, make the tips more compact and draw tiny dots densely.

Delphinium
Don't try to draw every detail in the cluster of small flowers. Keep the small buds single-colored and add multiple colors to the foreground flowers for contrast.

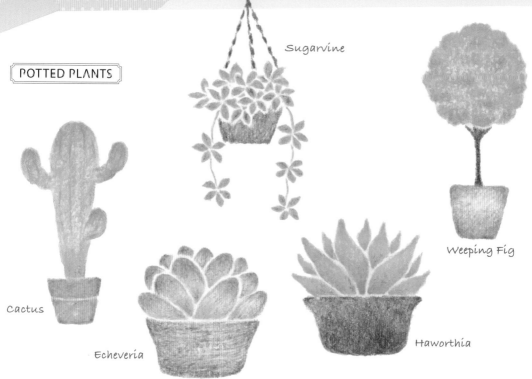

POTTED PLANTS

Sugarvine

Weeping Fig

Cactus

Echeveria

Haworthia

BEST TECHNIQUES

Cactus
To create a rounded look, gently layer green over yellow-green.

Succulents
To add thickness to the leaves and achieve a plump look, darken the colors at the bases and tips.

Hanging Plants
To create a soft volume, avoid drawing every leaf in great detail.

Shrubs
Intentionally create a bushy shape with both yellow-green and green. For pots with a whitish hue, lightly apply pale orange and orange to the edges and corners.

TREES

BEST TECHNIQUES

Deciduous Trees
Layer yellow-green, light blue, and green to create a round shape.

Coniferous Trees
Layer needle colors in a downward direction from top to bottom.

Apple Trees
To create the impression of apples obscured by leaves, lightly layer red here and there on the green foliage.

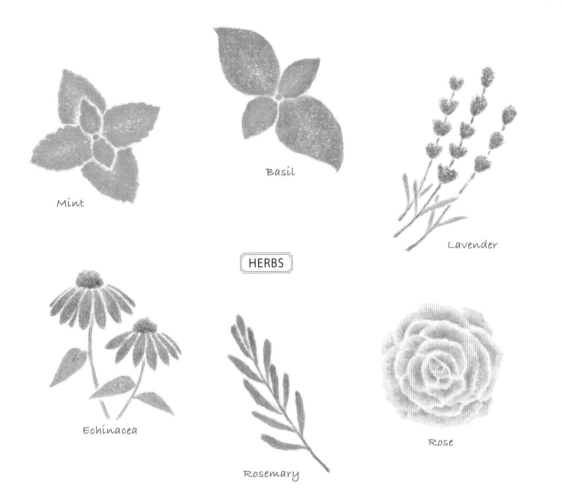

Mint

Basil

Lavender

HERBS

Echinacea

Rosemary

Rose

BEST TECHNIQUES

Mint
Intentionally create a frilly edge on the leaves. Lightly layer on different shades, such as orange.

Basil
Focus on a lush, dark green color for the large leaves.

Lavender
For the flowers, start with light blue and then gradually layer on pink and purple. Layer on blue and purple on the stems for balance.

Echinacea
After applying a light green base, lightly layer on red and purple.

Rosemary
Experiment with varying the saturation of blue and adding touches of purple to each leaf for subtle variation.

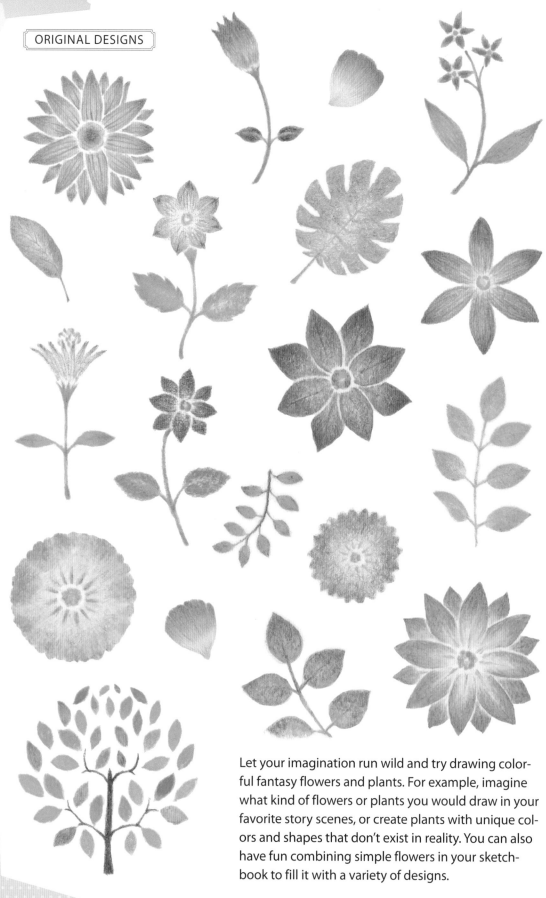

Let your imagination run wild and try drawing colorful fantasy flowers and plants. For example, imagine what kind of flowers or plants you would draw in your favorite story scenes, or create plants with unique colors and shapes that don't exist in reality. You can also have fun combining simple flowers in your sketchbook to fill it with a variety of designs.

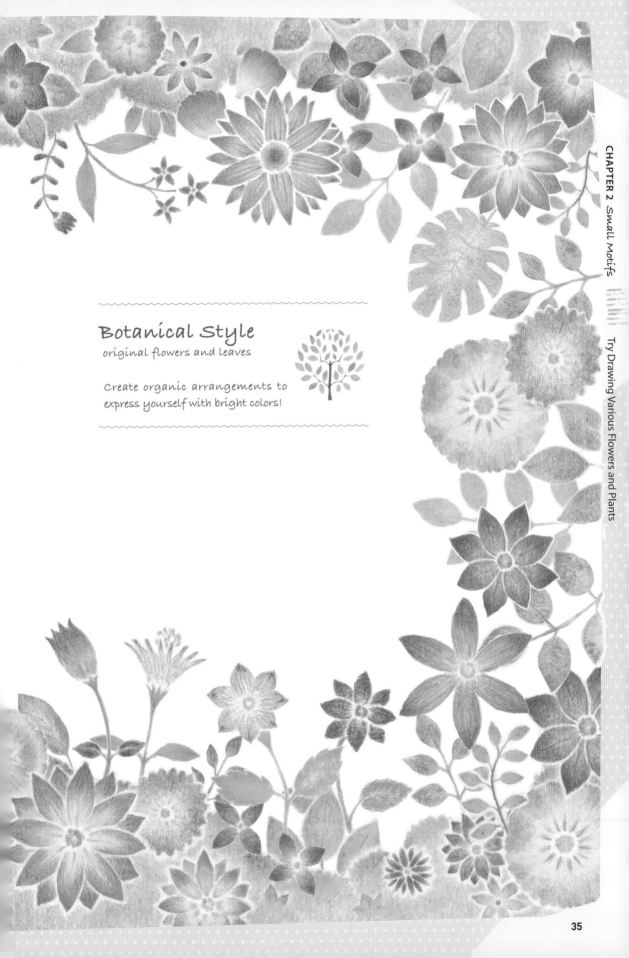

Botanical Style
original flowers and leaves

Create organic arrangements to
express yourself with bright colors!

Miscellaneous Items and Foods

Ribbons

Layering on various colors creates a three-dimensional effect, and using an eraser to finish adds soft light and shadows.

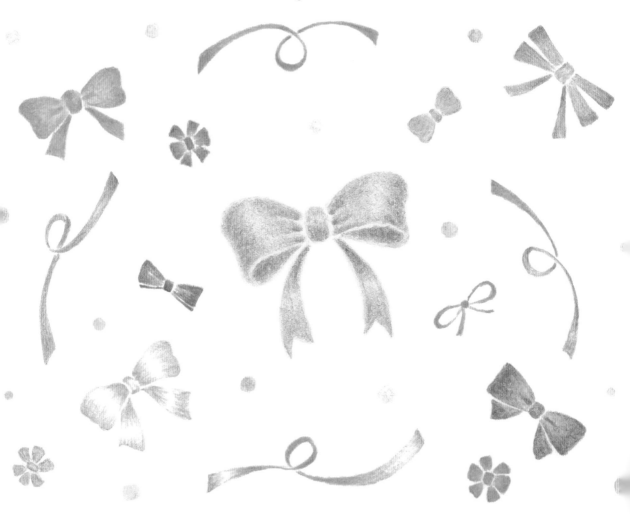

Cute, curly ribbons in red, purple and blue can be coordinated to create a greeting card-like charm. They are perfect for celebrations.

VIDEO Access the how-to video by typing the following URL into your web browser:

www.tuttlepublishing.com/
colored-pencil-drawings-and-doodles

For support, email us at
info@tuttlepublishing.com

COLORS

- Light Blue
- Pink
- Blue
- Purple

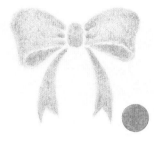

INSTRUCTIONS

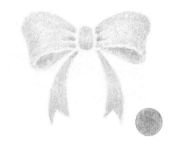

① Apply light blue evenly across the entire ribbon. Leave the edges from the underlying sketch white without coloring.

② Layer on blue to the loose ends and areas that are in shadow.

③ Apply pink lightly across the entire ribbon.

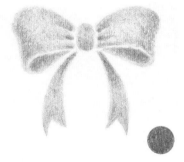

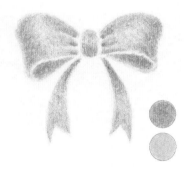

④ Layer purple onto the shaded areas you colored with blue in step 2.

⑤ Gradually layer blue and light blue across the entire ribbon to create a smooth gradient.

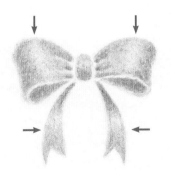

SKETCH

⑥ Use an eraser to gently create highlights on the outer edges of the curves, giving a sense of dimension to the ribbon.

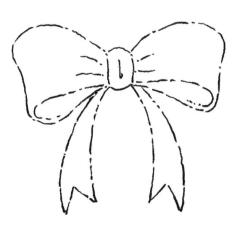

CHAPTER 2 *Small Motifs*

Miscellaneous Items and Foods

37

LESSON 5

Miscellaneous Items and Foods

Cupcakes

To depict a fluffy cake with creamy icing, it's important not to draw the outlines too strongly. A gentle touch is key.

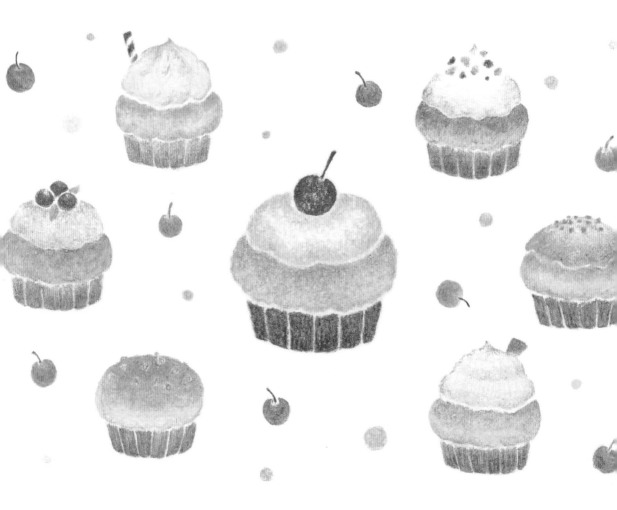

Once you've drawn the paper liner, cupcake and icing, try matching the appearance your favorite varieties—such as blueberry, chocolate-banana or caramel-nut—in your sketchbook.

VIDEO Access the how-to video by typing the following URL into your web browser:

www.tuttlepublishing.com/ colored-pencil-drawings-and-doodles

For support, email us at **info@tuttlepublishing.com**

COLORS

- Pale Orange
- Orange
- Brown
- Yellow
- Pink
- Red

INSTRUCTIONS

① Use pale orange to lightly color the cake portion.

② Layer yellow and orange onto the tones set down in step 1. Apply the colors gently in a circular motion to create a soft texture.

③ Lightly color the icing with pale orange, leaving the center of the cream white.

④ Apply pink and yellow lightly around the outline of the icing, adding a subtle touch of color.

⑤ Color the liner with brown and lightly layer orange on top.

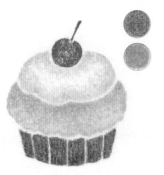

SKETCH

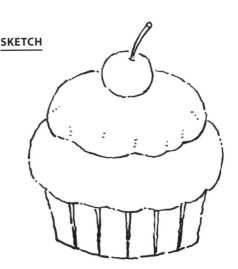

⑥ Apply red and orange lightly to the areas around the icing's shadows on the cake, and finally, draw the cherry.

Miscellaneous Items and Foods

French Bread

To achieve a natural gradient, lightly and carefully layer pale orange and yellow colors inside the orange and brown shades of the baked crust.

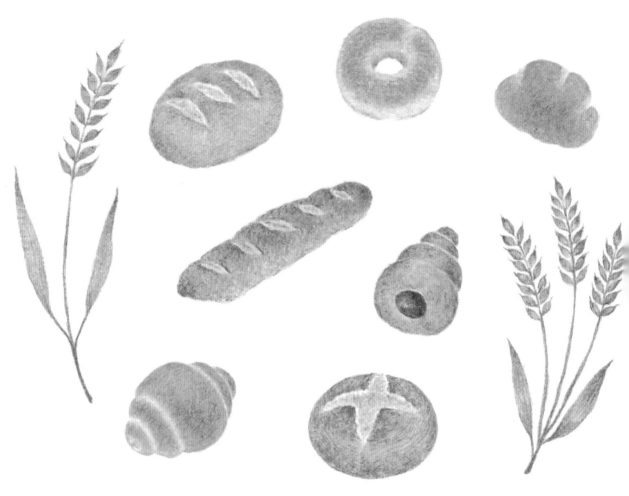

You can almost smell the aroma of this delicious-looking bread with the appearance of crisp, golden-brown crusts and soft interiors. Here, we'll take advantage of the paper's whiteness.

VIDEO Access the how-to video by typing the following URL into your web browser:

www.tuttlepublishing.com/colored-pencil-drawings-and-doodles

For support, email us at **info@tuttlepublishing.com**

COLORS

Pale Orange Orange

Yellow Brown

INSTRUCTIONS

① Apply a thin layer of pale orange all over. Leave the indentations uncolored.

② Layer on yellow lightly, following the contours, adding it to the color from step 1.

③ Apply orange slightly more liberally to the bread's outer surface.

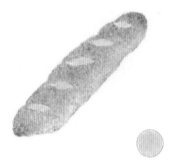

④ Layer on brown carefully, being mindful not to overwhelm the underlying colors. Make the ends of the bread slightly darker.

⑤ Lightly color the indentations with pale orange.

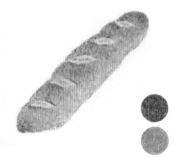

⑥ Apply brown more heavily along the edges of the indentations and add a thin layer of brown and orange inside the indentations to create the baked appearance. Adjust the entire drawing to finish.

SKETCH

Try Drawing Various Items and Foods

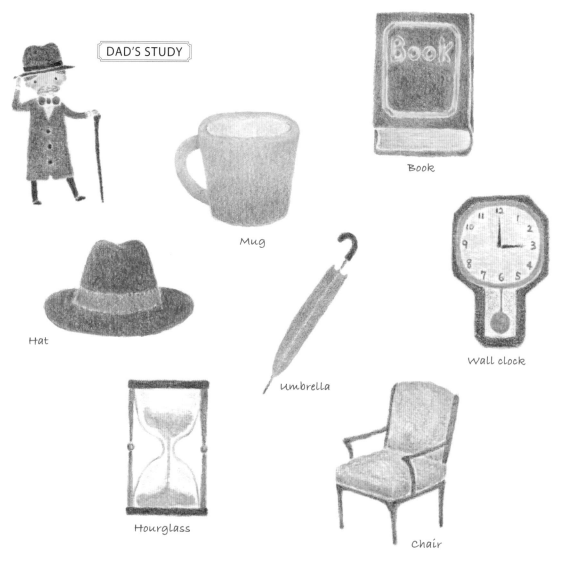

DAD'S STUDY

Book

Mug

Hat

Umbrella

Wall clock

Hourglass

Chair

BEST TECHNIQUES

Mug
Start by lightly coloring with pale orange, then apply a layer of light blue for a muted, dull color. Add a touch of brown and purple to the lower part of the cup to give it weight and depth.

Gentleman's Hat
After applying blue and orange, lightly layer brown over the entire hat to add depth to the color.

Hourglass and Wall Clock
Carefully draw straight and curved lines without distortion.

Book
Layer blue and green with roughly equal saturation. Mix in some purple toward the edges to avoid uniformity.

Umbrella
Layer green with blue and brown to achieve a deep, subdued color. Pay attention to keeping the lines straight.

Chair
For the cushion part, avoid overapplying color to make it look soft and not too heavily shaded.

WEEKEND PICNIC

Handbag

Suitcase

Hat

Notebook

Fork & spoon

Camera

Basket

Sun hat

BEST TECHNIQUES

Handbag
Mix a little brown into each part of the bag to create a sense of harmony.

Lady's Hat
Besides light blue, add shades of pink and orange gradually to outline and provide color. Leaving some parts white will make it appear whitish overall.

Notebook
Layer brown and orange over pale orange for a slightly worn appearance.

Camera
Layer light blue and brown with roughly equal intensity to achieve a grayish tone. Carefully draw both curved and straight lines.

Suitcase
After lightly coloring with pale orange, add yellow, orange and brown gradually. You can also add a worn texture with brown.

Fork and Spoon
Avoid over-coloring the inner part of the metal and use sharp blue for outlining, making the tips darker.

Sun Hat
Add various colors like yellow, orange, yellow-green and pink gradually to achieve a complex color palette.

Basket
Beside brown, layer orange and yellow-green over the basket.

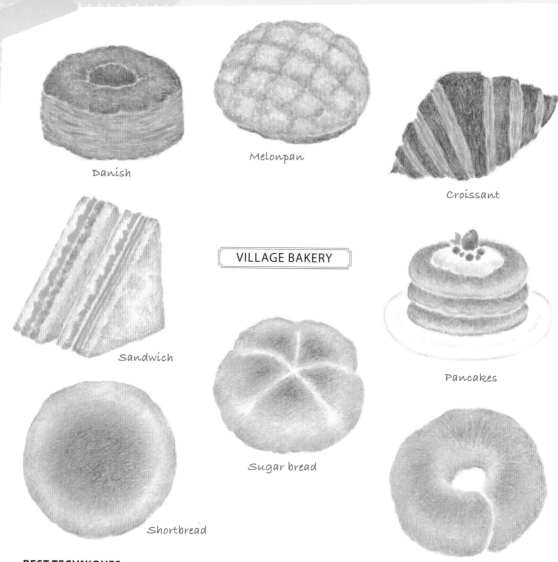

Danish

Melonpan

Croissant

VILLAGE BAKERY

Sandwich

Sugar bread

Pancakes

Shortbread

Bagel

BEST TECHNIQUES

Danish Pastry
Layer brown and red generously along the edges of the pastry dough to achieve a golden-brown appearance. Use an eraser to gently remove some color on the surface and parts of the toppings to add a three-dimensional effect.

Melonpan
For the surface cookie part, apply pale orange and yellow lightly, with a hint of yellow-green. Use orange to gently color the grooves in the pattern and layer brown on the outline of the bread and the lower bread dough.

Croissant
Apply pale orange and yellow over the entire pastry, then gradually layer orange and brown on the parts with a baked color. Use orange and brown to lightly draw lines to represent the layers.

Sandwich
Apply pale orange lightly to the corners and edges of the bread, and add a very light layer of orange and brown. Give the fillings a solid color to create a more defined look.

Pancakes
For the browning, gradually add orange, brown and red while balancing the colors.

Various Breads (Shortbread, Sugar Bread, Bagel)
Apply pale orange lightly, and then gradually layer orange and brown to create variations in browning.

TOWN PASTRY SHOP

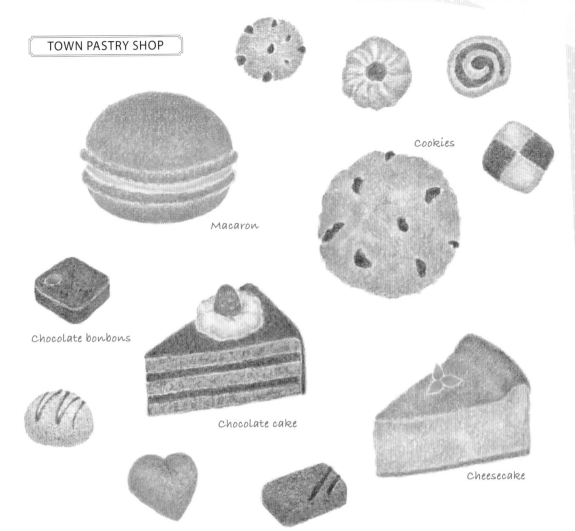

Cookies

Macaron

Chocolate bonbons

Chocolate cake

Cheesecake

BEST TECHNIQUES

Macaron
Start with a light coat of pale orange over the entire surface, then add a hint of pink and lightly layer red on the top and bottom. For the edges of the seams, draw gentle circles.

Chocolate Chip Cookie
Apply yellow and orange lightly, then create a toasted effect with brown to add dimension. Irregular outlines give a more natural finish.

Cookies
After applying pale orange, gradually layer yellow, orange, and brown to add browning. Mix a little orange into the chocolate dough part.

Chocolate Cake
For the dark chocolate parts, layer red and pink over brown to intensify the color. For the spongy cake and icing, apply pale orange as a base, then gently layer brown and pink.

Cheesecake
Apply pale orange and yellow lightly over the entire surface, and then use orange on the surface and brown on the bottom and edges, gradually intensifying the colors.

Chocolate Bonbons
Changing the colors you layer over brown can give a slightly different look to each morsel.

Drawing Sweet & Simple Monochromatic Illustrations

Colored pencils are renowned for their layering capabilities, but it can also be enjoyable to challenge yourself by using only one color. The meticulous process of shading and paying attention to details can be great practice for colored pencil illustrations.

☀ Simple and Versatile

Try creating illustrations using only one color, such as a serene shade of blue, for postcards, simple letters, notes and more.

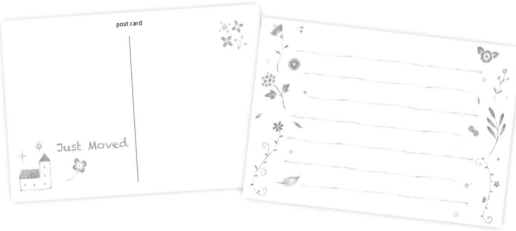

☀ Which Color to Use?

For monochrome illustrations, it's recommended to use a rich and calming color, particularly shades of blue. You can leave the paper white, create gradients carefully and explore various expressions using just one color.

CHAPTER 3

Detailed Motifs

In this chapter, you'll explore more involved motifs like houses and castles, as well as motifs with expressions and movement, such as birds, animals and children. The subtle differences in colored pencils will be reflected in your illustrations, so don't hesitate to draw multiple examples and discover your unique style.

Fairytale-like Buildings

Cottages with Colorful Roofs

Even though the roofs appear to be the same color, trying slight variations in color can make your illustration look more intricate.

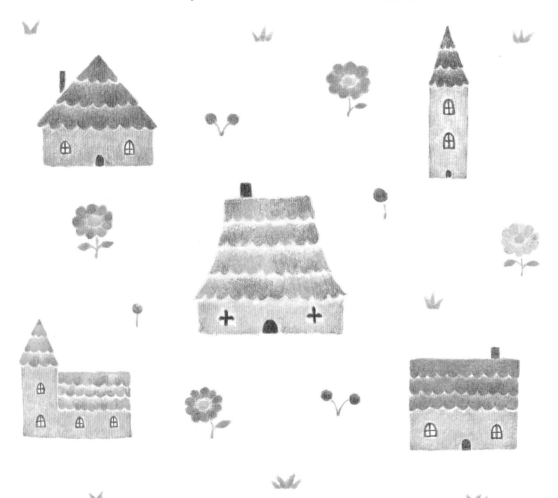

These are charming fairytale-like houses with large roofs. Instead of just blue roofs, try coloring them with various colors, arranging them in groups of three or four, and adding a little path to create a tiny village straight out of a fairy tale.

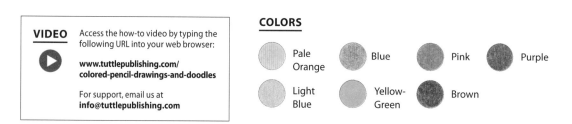

VIDEO Access the how-to video by typing the following URL into your web browser:

▶ **www.tuttlepublishing.com/ colored-pencil-drawings-and-doodles**

For support, email us at **info@tuttlepublishing.com**

COLORS

Pale Orange

Blue

Pink

Purple

Light Blue

Yellow-Green

Brown

INSTRUCTIONS

1 Start by lightly tinting the house facade with pale orange.

2 Color the roof with light blue, varying the color intensity in some places.

3 Layer blue over the roof, giving variations in intensity similar to step 2.

4 Apply yellow-green in a way that doesn't spill over into contiguous areas.

5 Use pink to add tones to areas not colored in step 4.

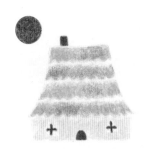

6 Draw windows, a door and a chimney with brown.

7 Add a very light layer of brown and pink to the outlines of the house facade. Finally, blend it with pale orange.

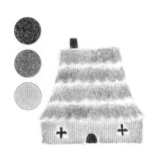

8 Enhance specific areas of the roof with purple. Finish by lightly applying blue and light blue to tie it all together.

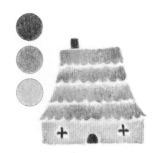

SKETCH

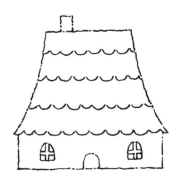

Fairytale-like Buildings

Castles and Towers with Spires

Even in a flat illustration that appears to be rendered primarily with a single color, adding a slight variation of color in key areas can change the overall expression.

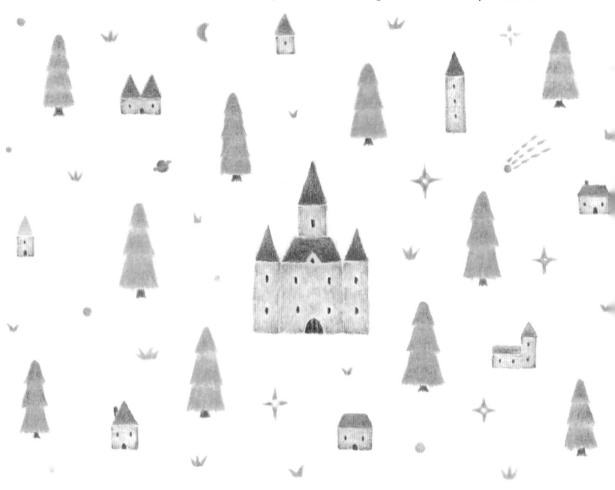

Castles are characterized by their tall, straight towers and large gates.
Apart from that, there isn't much difference from regular houses,
so feel free to draw various imaginative structures.

VIDEO Access the how-to video by typing the
following URL into your web browser:

**www.tuttlepublishing.com/
colored-pencil-drawings-and-doodles**

For support, email us at
info@tuttlepublishing.com

COLORS

| | | | |
|---|---|---|---|
| Pale Orange | Yellow | Red | Blue |
| Orange | Pink | Brown | Light Blue |

INSTRUCTIONS

① Start by lightly tinting the entire facade with pale orange.

② Layer on orange and yellow in some areas of the facade.

③ Use orange and pink to lightly color the roofs, not uniformly, but with variations and random layering.

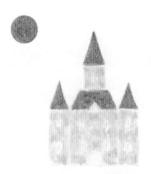

④ Carefully apply red over the roofs, being careful not to overwhelm the previously applied colors.

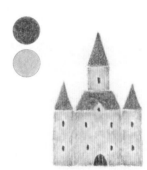

⑤ Fill in the windows and door with brown. Use brown and light blue to very lightly tone the outlines of the walls.

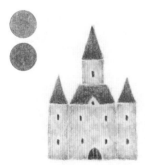

⑥ Add subtle shading to the roofs with blue. Finish by blending red on top.

SKETCH

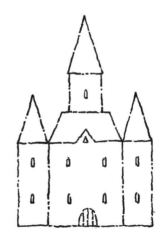

Try Drawing a Fairytale-like Town

Even simple individual houses can become part of a fairytale-like town
when you very their sizes and add colorful pointed roofs.
If you draw them small and arrange them into a pattern,
it could form the basis of a cute wrapping paper.

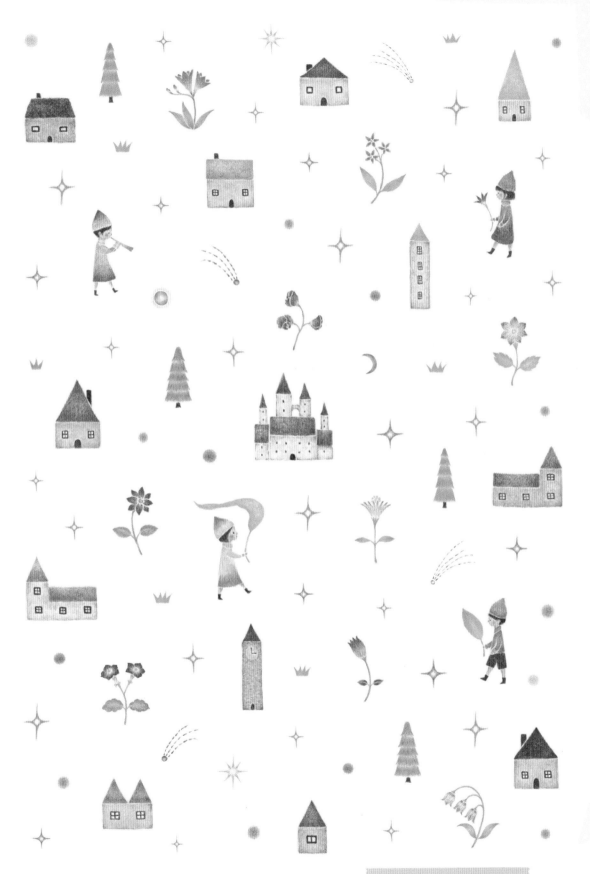

Small Birds and Forest Animals
Flycatchers

For small details like the eyes and mouth, it's convenient to use a graphite pencil as you can make corrections easily. Graphite pencil drawing should be done last because it can make the colors muddy otherwise.

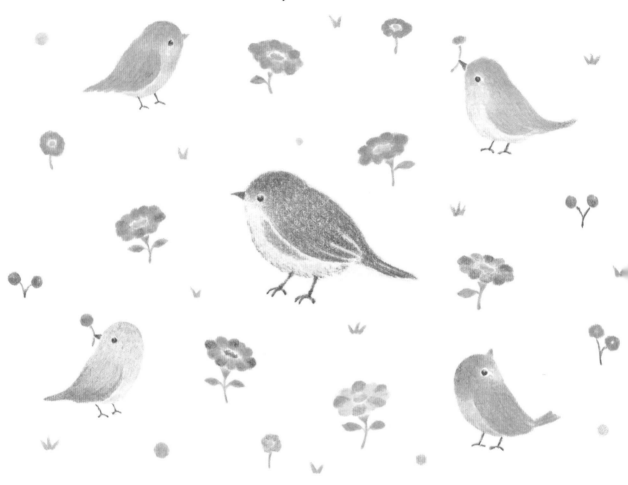

The blue-and-white flycatcher, adorned with azure feathers, is said to be ornamentation exclusive to the males. Discovering new facts through observation and research can add to the enjoyment of drawing illustrations.

VIDEO

▶

Access the how-to video by typing the following URL into your web browser:

www.tuttlepublishing.com/colored-pencil-drawings-and-doodles

For support, email us at
info@tuttlepublishing.com

COLORS

Pale Orange Blue Orange ✏ Graphite Pencil

Light Blue Purple Brown

INSTRUCTIONS

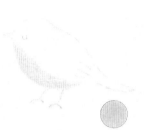

① Start by lightly coloring the belly with pale orange.

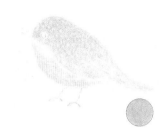

② Use light blue to lightly color the head and the entire feathered body.

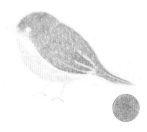

③ Layer blue over the areas colored in step 2, carefully following the flow of the feathers.

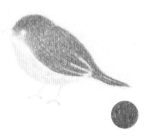

④ Lightly shade the entire area of blue-colored feathers with purple. Gradually layer the color up to the tips of the feathers, and refine with light blue and blue.

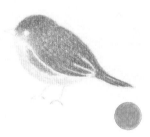

⑤ Use orange to color a part of the body.

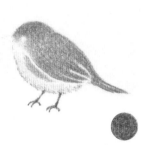

⑥ Use brown to softly outline the belly. Gradually draw the legs as well.

SKETCH

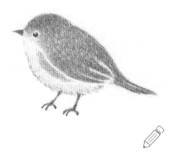

⑦ Use a pencil to draw in the eyes, beak and the tips of the feet. For the tips of the feet, just draw short lines.

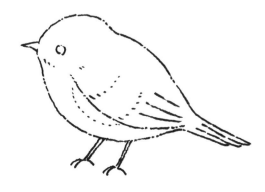

Small Birds and Forest Animals

A Cat

The positioning of the eyes and mouth is important, so keep the preliminary lines on the darker side. Draw the whiskers lightly at the end.

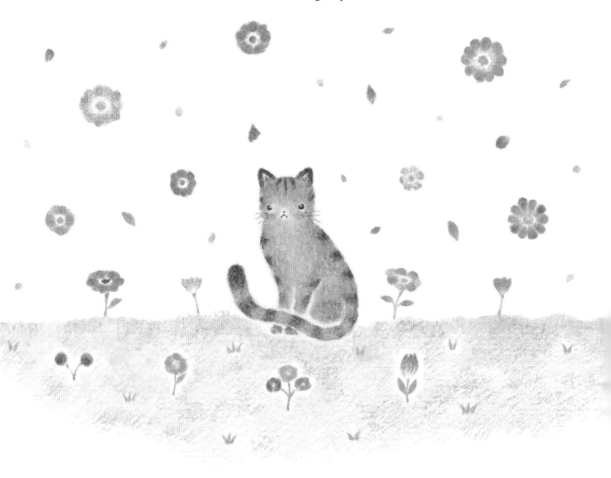

Draw a cat sitting in a meadow, feeling the spring breeze. The look of the illustration can change dramatically with subtle differences in expression. Cats, with their various colors, patterns and poses, are fun animals to draw.

VIDEO Access the how-to video by typing the following URL into your web browser:

www.tuttlepublishing.com/ colored-pencil-drawings-and-doodles

For support, email us at **info@tuttlepublishing.com**

COLORS

Pale Orange Brown Graphite Pencil

Orange Pink

INSTRUCTIONS

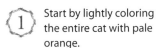

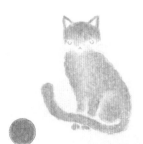

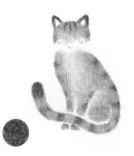

1. Start by lightly coloring the entire cat with pale orange.

2. Layer orange over it. Keep the face and the center of the body lighter, allowing the pale orange from step 1 to show through.

3. Add patterns with brown. Progressively layer on color multiple times to create a soft, textured look.

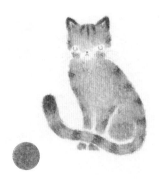

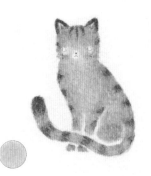

4. Lightly layer pink on the ears, cheeks, and chest area.

5. Use pale orange to blend the color over the entire cat, focusing particularly on the belly.

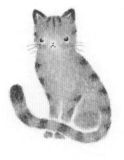

SKETCH

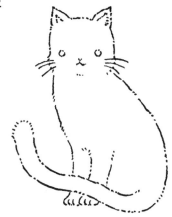

6. Draw the eyes, mouth and whiskers with a graphite pencil. Draw the whiskers by releasing pressure as you move from the inside to the outside.

57

LESSON 11

Small Birds and Forest Animals

A Hedgehog

Gently layer various colors to draw the spines. Adding a hint of pink is essential.

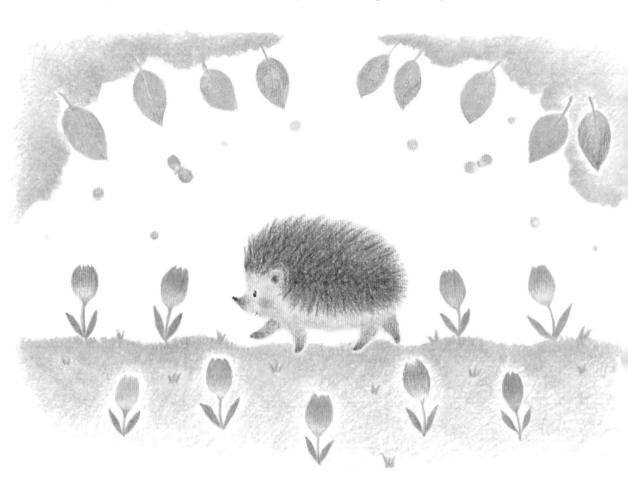

Draw a plump, round hedgehog strolling through a tulip field. While it may seem challenging at first, you can create the appearance of spines by drawing them smoothly side-by-side in various colors.

VIDEO

▶

Access the how-to video by typing the following URL into your web browser:

www.tuttlepublishing.com/ colored-pencil-drawings-and-doodles

For support, email us at
info@tuttlepublishing.com

COLORS

- Pale Orange
- Orange
- Red
- Yellow-Green
- Pink
- Brown
- Purple
- Graphite Pencil

INSTRUCTIONS

① Begin by coloring the body with pale orange. Leave the tips of the spines untouched and lightly color the entire body.

② Apply a very light layer of pink over the pale orange and blend it in. Draw the spines while paying attention to their direction.

③ Use orange to draw the entire set of spines.

④ Draw the spines with brown. Start with a lighter touch and make some areas slightly darker.

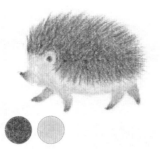

⑤ Use brown to draw the ears, nose and the tips of the paws. Shade the paws on the opposite side with brown and blend them with pale orange.

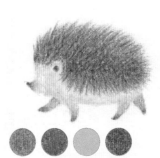

⑥ Add a few spines here and there using red, purple, yellow-green, and other colors, then blend them in with brown.

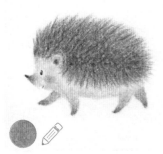

⑦ Apply a light layer of pink to the cheeks, ears, nose and the tips of the paws. Use a pencil to draw the eyes, nose and mouth.

SKETCH

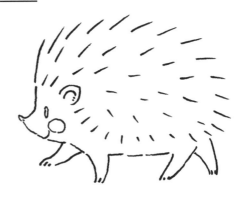

Try Drawing Birds and Forest Animals

Try freely drawing animals that live in the forest. In addition to observing real animals and drawing them, I encourage you to also try creating your own imaginary creatures. Animals covered in fur or feathers will have a soft and fluffy appearance when you draw using short pencil strokes.

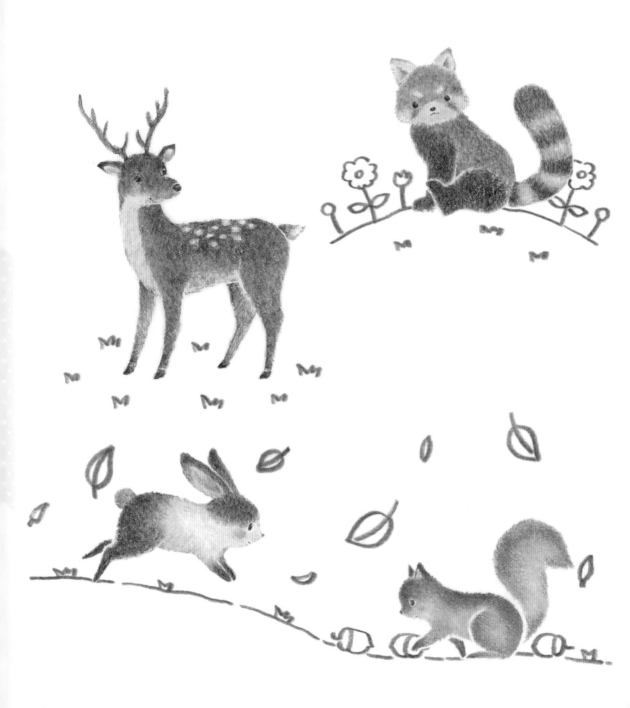

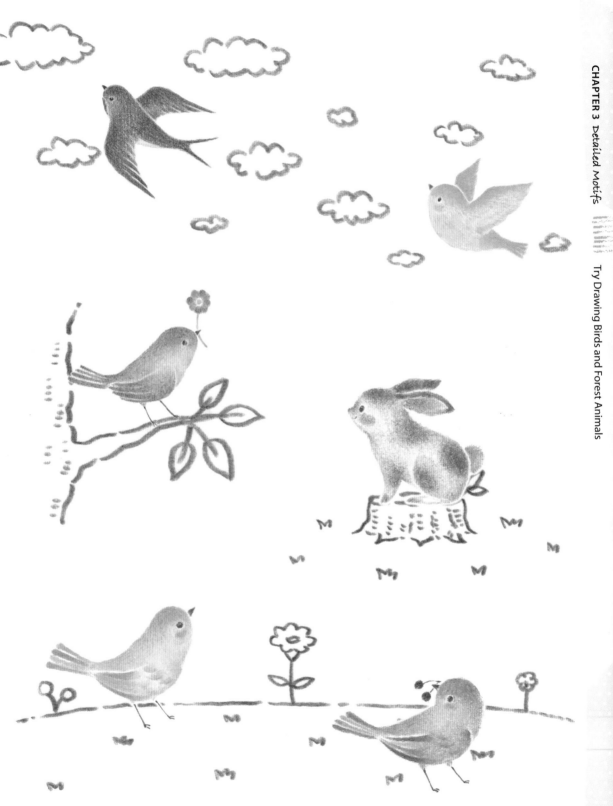

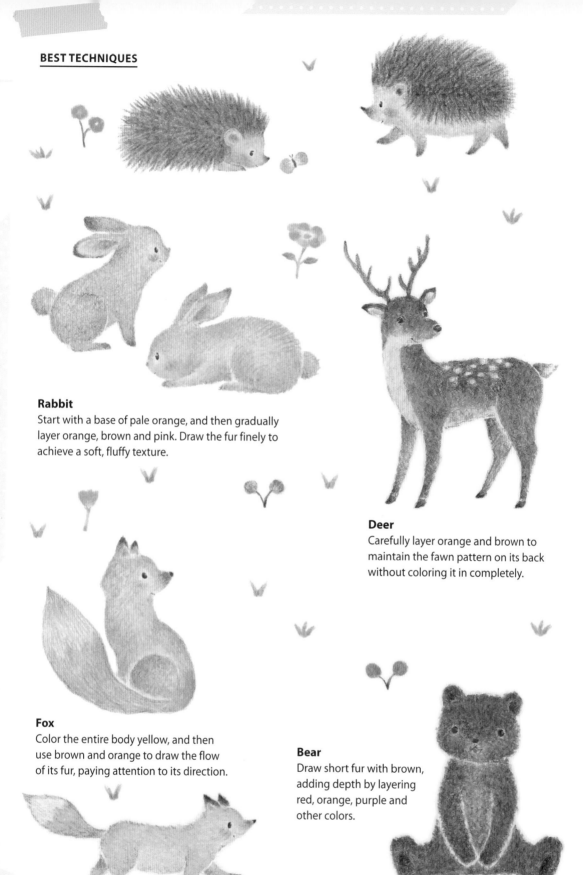

Rabbit
Start with a base of pale orange, and then gradually layer orange, brown and pink. Draw the fur finely to achieve a soft, fluffy texture.

Deer
Carefully layer orange and brown to maintain the fawn pattern on its back without coloring it in completely.

Fox
Color the entire body yellow, and then use brown and orange to draw the flow of its fur, paying attention to its direction.

Bear
Draw short fur with brown, adding depth by layering red, orange, purple and other colors.

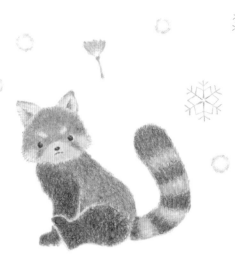

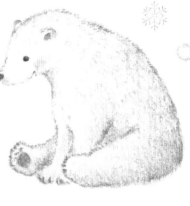

Polar Bear

Outline the white fur with light blue, blue and pink, drawing them finely like short fur. In the shadowed areas, layer blue lightly.

Red Panda

Because the facial markings are intricate, take your time to draw them while looking at a reference photo. Lighter areas can be created by layering orange, red and brown thinly. Darker areas can be drawn by first applying brown, and then layering black.

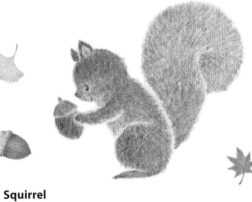

Squirrel

Start with a base of pale orange, and then lightly layer orange, adding brown with many short strokes to indicate fine fur. It's also okay to add different colors like red or pink here and there.

Sheep

Color the entire body with pale orange, then lightly layer orange, pink and brown, drawing them in small circles to create a textured effect.

BEST TECHNIQUES

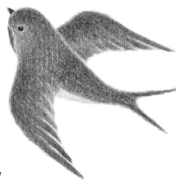

Japanese Long-tailed Tit
Gently apply a very light layer of pale orange on its head and around its belly. Use light blue and pink to add subtle shadows. For outlining, use very light black or light blue to create short strokes.

Swallow
For the dark feathers, apply blue and purple as a base, and then use black on certain parts like the head and wingtips to finish.

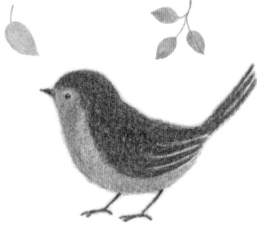

Robbin
The light brown on its body can be created by lightly layering pale orange, brown and blue with similar intensity. Make the wingtips slightly pointed to give it a more refined appearance.

Budgerigar
Avoid applying too much color to the whitish parts. Apply a light layer of yellow and use orange to make only certain portions darker.

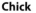

Parakeet
Use light blue or blue to lightly outline the white areas.

Chick
Layer yellow and orange gently in a circular motion to create a fluffy outline.

Shiba Inu
Using orange and brown, carefully draw short fur by gradually layering it in short strokes.

Miniature Dachshund
Layer brown carefully following the flow of the fur, adding a hint of red for depth.

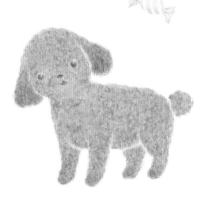

Toy Poodle
For the lighter fur color, start with a very light layer of pale orange, and then layer brown and orange with similar intensity. Draw small, gentle circles to create the texture.

Golden Retriever
Apply yellow overall and add very light layers of orange and brown extending from the edges of the constituent parts. Use these colors to depict the fur's length, particularly around the belly and tail.

Landscapes with Children

A Girl Picking Flowers

Adding pink to small areas like cheeks and limbs can create a sense of warmth.

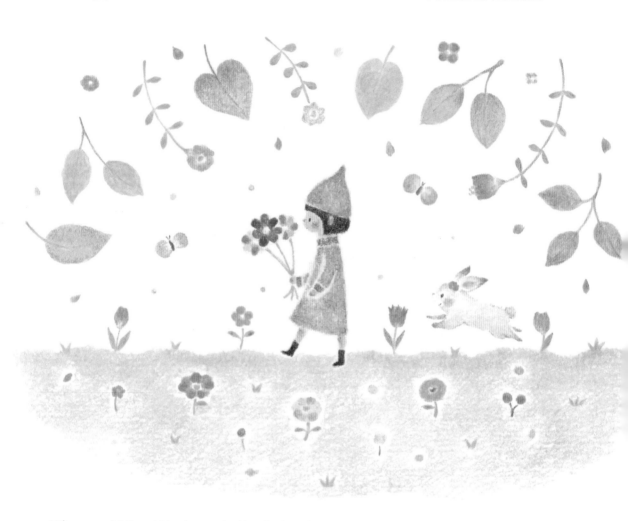

Where could the girl in the conical hat be heading with her bouquet? Adding movement to the pose and small details can make the illustration feel like a story.

VIDEO Access the how-to video by typing the following URL into your web browser:

**www.tuttlepublishing.com/
colored-pencil-drawings-and-doodles**

For support, email us at
info@tuttlepublishing.com

COLORS

Pale Orange

Yellow

Yellow-Green

Orange

Pink

Graphite Pencil

Brown

Red

Light Blue

Blue

INSTRUCTIONS

① For her clothing, start with a light layer of pale orange, and then add a similarly light layer of yellow.

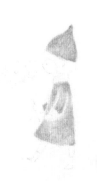

② Apply a slightly heavier layer of orange to the periphery of her clothing and hat.

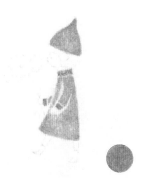

③ Use pink to lightly tint her entire outfit, including the collar.

④ Color her face, ears and limbs with pale orange.

⑤ Use brown to color her hair and shoes.

⑥ Draw the flowers using pink, red, yellow and orange for the petals and light blue and blue for the stems.

⑦ Apply a light layer of pink to her nose, cheeks, ears and limbs.

⑧ Use a graphite pencil to draw in her eyes and mouth, and use it to touch up the ends of her hair.

SKETCH

Landscapes with Children

A Boy Reading a Book

The expressions of the eyes and mouth that you draw last are fine details, so take care to draw them small.

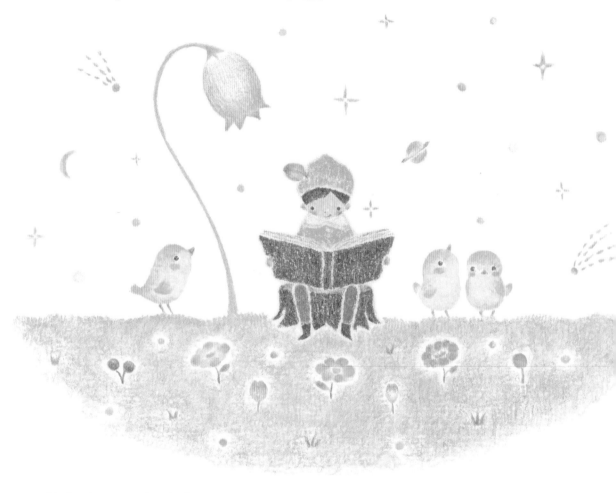

Under the starry sky, the boy is engrossed in reading by the light of the flower lamp—what kind of story could he be reading? Depending on your imagination, you have the freedom to make the starry sky darker or brighter.

VIDEO Access the how-to video by typing the following URL into your web browser:

www.tuttlepublishing.com/colored-pencil-drawings-and-doodles

For support, email us at info@tuttlepublishing.com

COLORS

Yellow-Green

Blue

Brown

Red

Light Blue

Pale Orange

Orange

Yellow

Pink

Graphite Pencil

DIRECTIONS

1. Start by lightly coloring the hat and cloak with yellow-green, and then add a light layer of light blue, particularly at the edges of the collar and the tip of the hat.

2. Use light blue for the collar and buttons, and blue for the pants. Tint the face, ears and hands with pale orange.

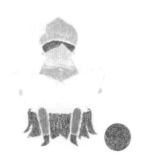

3. Color the hair, shoes and stump with brown. Be mindful to color the stump vertically.

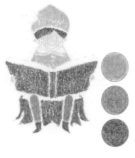

4. Layer orange, red and brown lightly to color the book's cover.

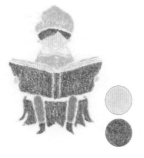

5. For the pages of the book, lightly apply pale orange and draw a few thin lines with brown to indicate the page edges.

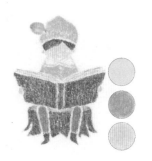

6. Apply a light layer of yellow to the decoration on the hat, and then layer it with orange. Use pale orange to color the cross-section of the stump.

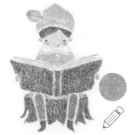

7. Add a light layer of pink to the cheeks, ears and hands. Use a graphite pencil to draw the eyes, nose and mouth, and use it to touch up his hair.

SKETCH

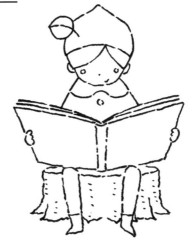

Try Drawing the Composition "Gnomes and Children in the Forest"

What kind of life do the gnomes living in the forest lead? Children have come to play in the forest as well. When drawing people, pay attention to their actions, expressions and accessories, and try to be creative. In this way, you can make the illustration feel like it's telling a story.

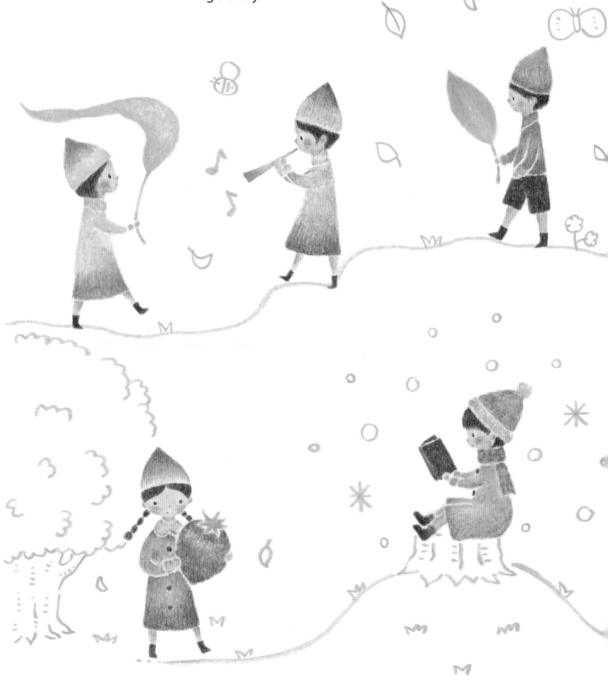

Background Illustrations Drawn with Simple Lines

In addition to the method of solid shading with colored pencils, here I introduce backgrounds drawn only with lines.

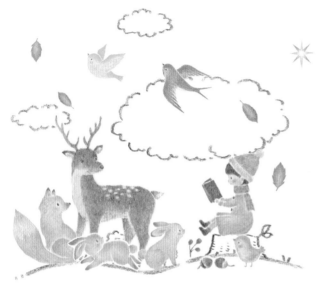

 Expert Tip

Backgrounds drawn with lines alone are simple and serve as the perfect supporting role to highlight the main motif. Leave some lines broken; a background drawing with a somewhat unfinished outline gives a relaxed, pleasingly unpolished impression.

Line Drawing Samples

Start by tracing the illustrations in the book. Gradually add simple freehand motifs and imbue them with your unique touch.

CHAPTER 4

Seasonal Motifs

Here, we'll explore motifs related to the animals, plants
and seasonal events that accompany the changing seasons.
By employing seasonal motifs, you can herald the arrival
of each season in your daily life through illustrations drawn
to decorate planners, journals and letters.

The Pastel Shades of Spring

Strawberries

Because the seeds are small and difficult to see, erasing the graphite pencil sketch lines at step 7 makes them easier to depict.

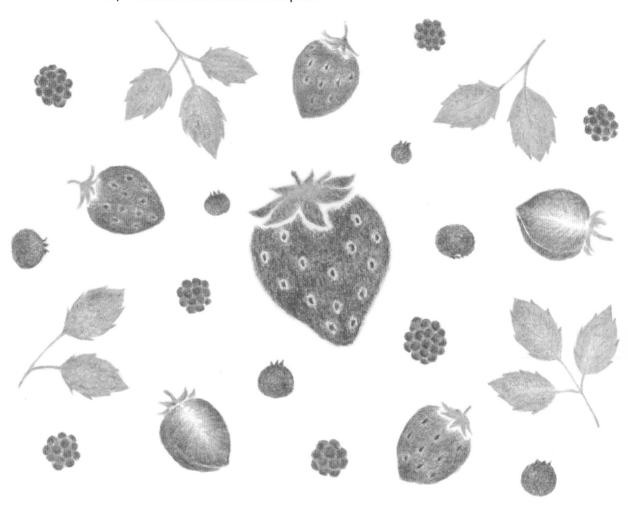

Here is a charming strawberry that signifies the arrival of spring. Drawing the tiny seeds meticulously gives it a realistic appearance. With such a rich variety in shape and color, all looking delightful, try drawing different kinds of berries!

VIDEO Access the how-to video by typing the following URL into your web browser:

www.tuttlepublishing.com/ colored-pencil-drawings-and-doodles

For support, email us at **info@tuttlepublishing.com**

COLORS

Pink Red Green

Orange Yellow-Green

INSTRUCTIONS

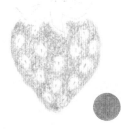

① Lightly color the fruit portion with pink. Leave a small margin around the seeds uncolored.

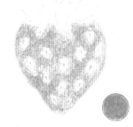

② Layer orange on top of step-1 color in random isolated areas.

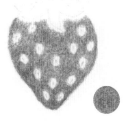

③ Lightly layer the entirety of the strawberry fruit with red. Ensure that you don't overwhelm the base color.

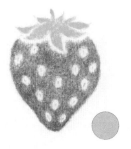

④ Color the entire calyx with yellow-green.

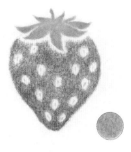

⑤ Layer green onto the step-4 color. Darken the tips.

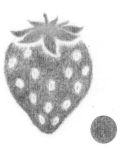

⑥ Layer red on the tips of the calyx to add depth of color to create a unified look with the fruit.

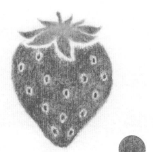

⑦ Draw the seeds with red. Finally, narrow the gaps around the seeds by filling them in with red to adjust.

SKETCH

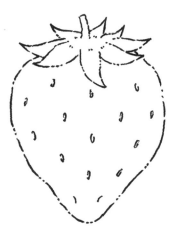

Try Drawing the Colors of Spring

In this illustration, cherry blossoms are in bloom, indicating the full arrival of spring. In the warm breeze, the flurry of fluttering petals fascinates the Hina dolls. Even within a single motif, the expression of cherry blossoms changes depending upon whether you are looking at a group from a distance, one detailed subject up close or just a single petal in focus. This diversity of expression makes it a rewarding motif to draw.

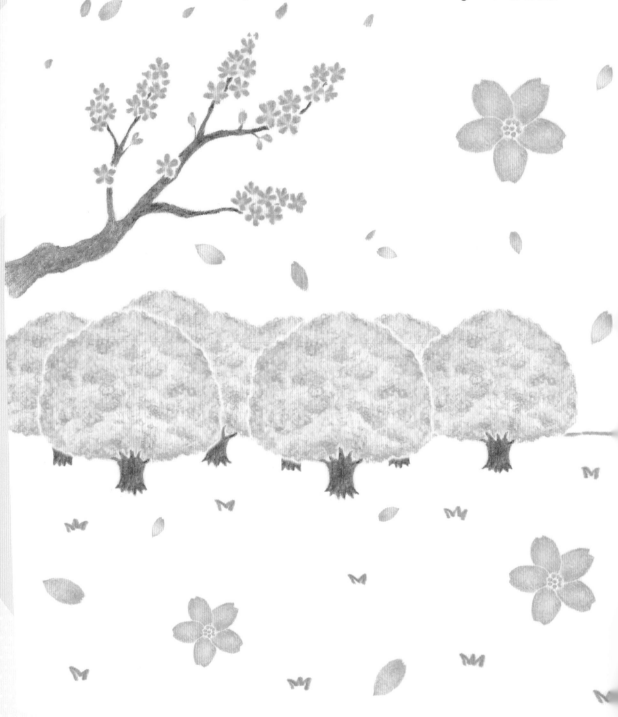

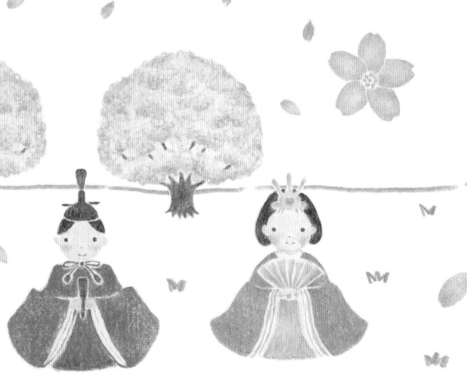

BEST TECHNIQUES

Tri-colored Dumplings (*Sanshoku Dango*)
For the white dumplings, just faintly color the edges with pale orange. For the muted green dumplings, layer a light brown over green.

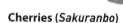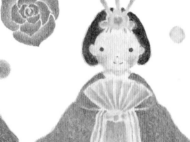

Cherries (*Sakuranbo*)
To give it a highlight, don't color the center of fruit too darkly. Finally, use an eraser to blend it smoothly.

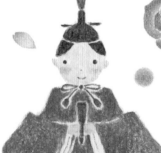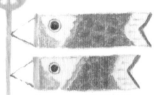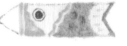

Hina Dolls (*Ohinasama*)
For the Emperor doll's kimono, layer blue, purple and a bit of black. For his cap (eboshi), color with blue and then overlay with black. For the Empress doll's kimono, overlay pink and orange on top of red.

Carp Streamers (*Koinobori*)
Overlaying similar colors, like blue and light blue or red and orange, will create a simple cohesion.

Easter Egg
Starting with a coat of pale orange makes the colors layered on top softer. Color carefully while leaving white lines and patterns.

78

Cherry Trees (*Sakura no Ki*)
Having variations of darker and lighter parts in the pink gives a natural appearance. Adding a bit of pink to the trunk provides a sense of harmony.

Cherry Blossoms (*Sakura no Hana*)
Starting with a light coat of pale orange and then adding pink gives a soft color. Layer on more pink toward the tips of the petals.

Lotus Flower (*Renge*)
It makes a natural-looking impression if the petal widths are somewhat uneven. Lightly overlay pink on the stems and leaves.

Horsetail (*Tsukushi*)
Keeping the patterns and nodes somewhat random looks more natural.

Rape Blossoms (*Nanohana*)
Overlaying orange or light green on yellow ensures that the yellow flowers don't merge into an undefined mass.

The Vivid Colors of Summer

Goldfish

When drawing the tips of the fins, gently stroke them with a relaxed touch to evoke the softly swaying underwater movement.

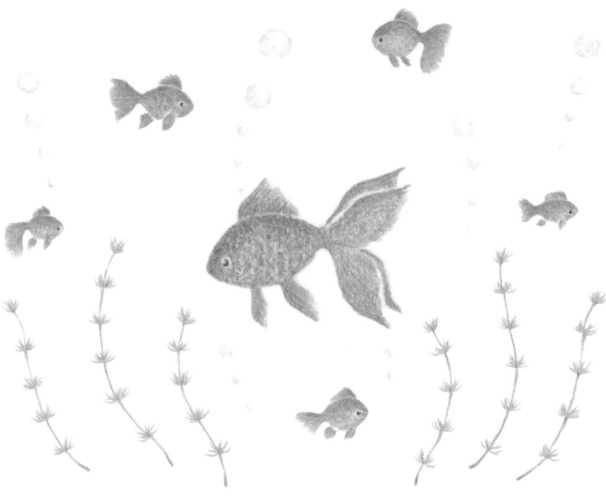

Drawing a goldfish swimming in the water with softly rendered fins can convey a sense of weightlessness. Furthermore, adding bubbles and aquatic plants enhances the impression of an underwater environment.

| VIDEO | Access the how-to video by typing the following URL into your web browser:

**www.tuttlepublishing.com/
colored-pencil-drawings-and-doodles**

For support, email us at
info@tuttlepublishing.com |
| --- | --- |

COLORS

Yellow

Red

Orange

Graphite
Pencil

INSTRUCTIONS

 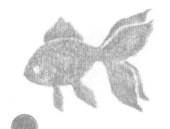 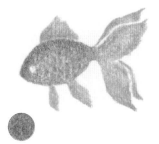

1 Lightly tint the fins and the area around the belly with yellow.

2 Expand the area of color beyond the tinted regions from step 1 with orange, covering the entire body.

3 Use red to color the body. Be mindful of the scales and layer red in small semicircles.

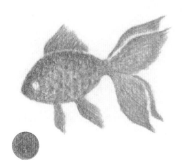 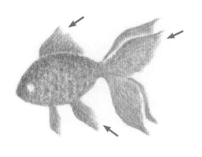

4 Draw the lines of the fins with red. Leaving the ends of the fins soft and free of outlining will create a soft appearance.

5 Use an eraser to gently remove some color from the tips of the fins to make them slightly translucent.

SKETCH

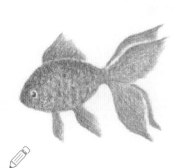 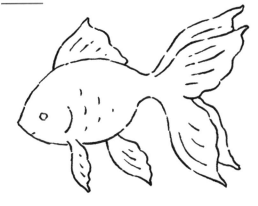

6 Draw the eyes with a graphite pencil.

CHAPTER 4 *Seasonal Motifs*

The Vivid Colors of Summer

81

Try Drawing the Colors of Summer

A scene of bursting fireworks lighting up the sky above a beach conveys nostalgic charm. Leaving a white background while still depicting certain features of a night-time sky can set a light and whimsical atmosphere. Instead of filling in the entire scene with colored pencils, featuring loosely rendered line art against white makes for a charming illustration.

CHAPTER 4 *Seasonal Motifs* Try Drawing the Colors of Summer

BEST TECHNIQUES

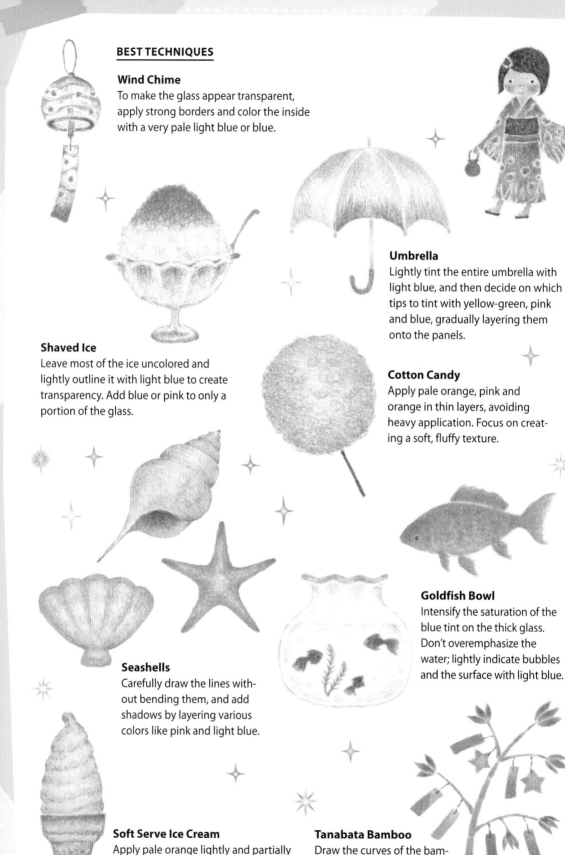

Wind Chime
To make the glass appear transparent, apply strong borders and color the inside with a very pale light blue or blue.

Umbrella
Lightly tint the entire umbrella with light blue, and then decide on which tips to tint with yellow-green, pink and blue, gradually layering them onto the panels.

Shaved Ice
Leave most of the ice uncolored and lightly outline it with light blue to create transparency. Add blue or pink to only a portion of the glass.

Cotton Candy
Apply pale orange, pink and orange in thin layers, avoiding heavy application. Focus on creating a soft, fluffy texture.

Goldfish Bowl
Intensify the saturation of the blue tint on the thick glass. Don't overemphasize the water; lightly indicate bubbles and the surface with light blue.

Seashells
Carefully draw the lines without bending them, and add shadows by layering various colors like pink and light blue.

Soft Serve Ice Cream
Apply pale orange lightly and partially layer with brown and orange for the outline. Leave the interior bright with the paper's white showing through.

Tanabata Bamboo
Draw the curves of the bamboo and the tanzaku (paper strips) delicately to create a graceful appearance.

Wisteria
Layer the colors while using an eraser to maintain the white space between the small flowers.

Sunflower
Add orange and yellow-green to the yellow petals, varying the intensity of the colors on adjacent petals.

Morning Glories
Leave white between the petals when applying the colors. Apply a hint of pink or purple to the leaves.

Hydrangea
Color individual flower clusters with blue and red first, and then lightly shade the surrounding areas with light blue or pink.

Peach
Lightly apply pale orange and gently apply several layers of pink. Add a touch of yellow.

Blueberries
Vary the intensity of blue and red for each berry to create bluish-purple and reddish-purple hues.

Watermelon
Don't oversaturate the red parts; allow the paper texture to show through to maintain a textured look.

Bananas
In addition to yellow, layer orange, yellow-green, and brown gradually along the ridges to create the look of three-dimensionality.

The Warm Colors of Autumn

Mushrooms

Adding layers of various colors will create the illusion of depth.
Don't be bound by preconceived notions, and freely layer the colors.

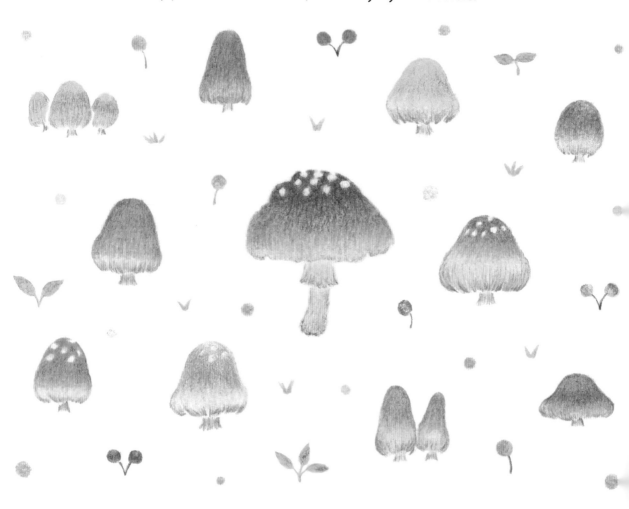

Mushrooms are essential elements for portraying a shaded forest floor.
Try drawing various mushrooms with different sizes and shapes.
It's also cute to add small animals sitting atop the mushroom caps.

VIDEO Access the how-to video by typing the
following URL into your web browser:

www.tuttlepublishing.com/
colored-pencil-drawings-and-doodles

For support, email us at
info@tuttlepublishing.com

COLORS

Pale Orange Orange Brown

Yellow Red Yellow-Green

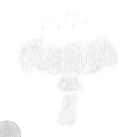

INSTRUCTIONS

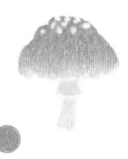

(1) Lightly tint the stem and the lower half of the mushroom cap with pale orange.

(2) Use yellow to lightly layer over the center of the mushroom cap and the tinted regions from step 1.

(3) With orange, create a gradient from top to bottom, avoiding the spores. Erase the outlines of the spores with an eraser.

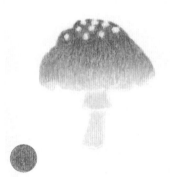

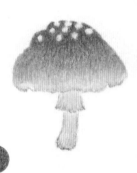

(4) Apply red over the color laid down in step 3. Maintain the gradient by coloring the upper half of the cap heavily and the lower half lightly.

(5) Add a bit of brown to the upper half of the mushroom cap. Make the base of the stem and the edge of the cap slightly darker.

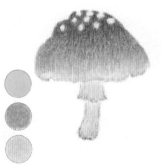

(6) Introduce some yellow-green here and there on the mushroom cap and stem. Finally, blend the entire mushroom with colors like orange and pale orange.

SKETCH

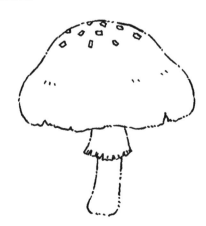

Try Drawing the Colors of Autumn

Here are two illustrations for autumn: the one below depicts a forest with falling leaves, and the one on the facing page depicts colorful pastel mushrooms in a lively pattern. By adding communing forest animals as the central characters in both illustrations, you can suggest an unspoken story in your artwork.

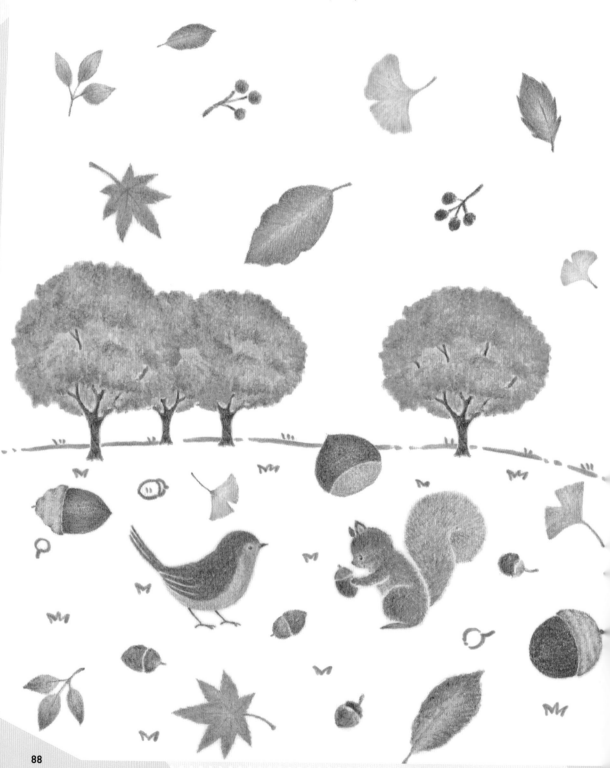

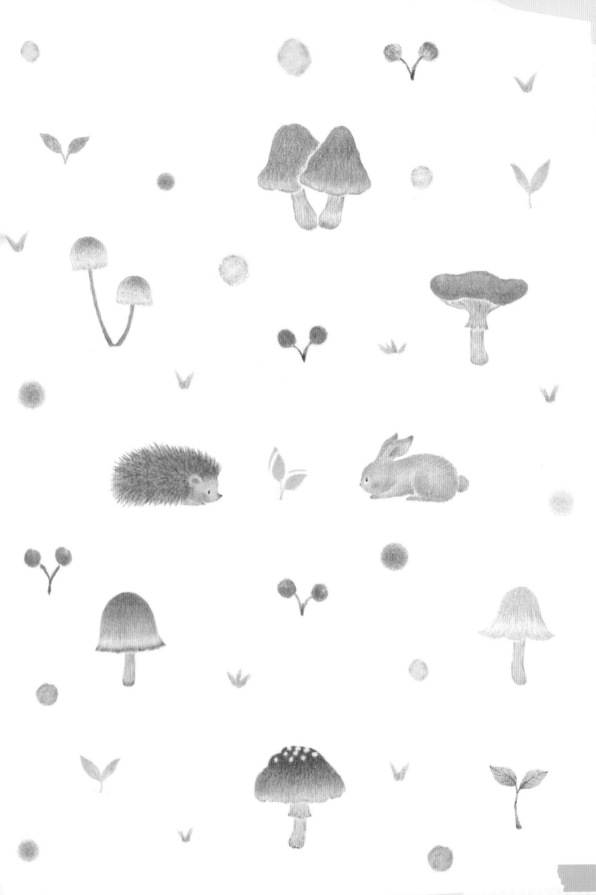

BEST TECHNIQUES

Moon-viewing Provisions

Start by coloring the dumplings and pampas grass with pale orange, and then lightly layer brown over them.

Persimmon

Apply orange and layers of red to achieve a rich color. Use an eraser to gently remove color for highlights.

Roasted Sweet Potatoes

For the skin color, liberally layer purple, brown, red and other colors.

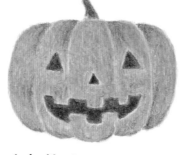

Chestnut

Express a deep brown color by layering red and purple on brown.

Jack-o'-Lantern

Color the whole pumpkin with orange and then layer red and brown, making vertical strokes with the pencils.

Grapes

Pre-tint each grape with red, blue and pink, and then lightly layer purple, varying the color for each grape.

Nuts

Layer multiple colors like red and purple on top of brown to express a rich color.

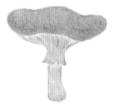

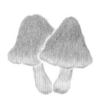

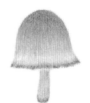

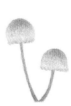

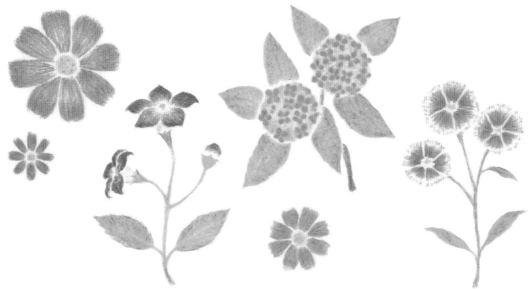

Cosmos
Layer not only pink but also red and orange with varying intensity.

Balloon Flowers
Create a gradient with blue and pink, and then tint the tips of the flowers with purple.

Fragrant Olive
After drawing some flowers, lightly tint the remaining parts with orange to represent a rounded cluster of flowers.

Fringed Pink
Outline the flowers with a fringe of pink to depict the white patterns.

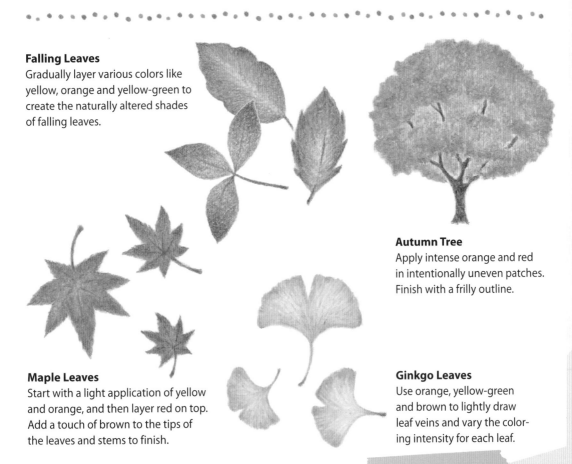

Falling Leaves
Gradually layer various colors like yellow, orange and yellow-green to create the naturally altered shades of falling leaves.

Autumn Tree
Apply intense orange and red in intentionally uneven patches. Finish with a frilly outline.

Maple Leaves
Start with a light application of yellow and orange, and then layer red on top. Add a touch of brown to the tips of the leaves and stems to finish.

Ginkgo Leaves
Use orange, yellow-green and brown to lightly draw leaf veins and vary the coloring intensity for each leaf.

The Cool Jewel Tones of Winter

A Snowman

Connect various colors for the outline, and make sure to preserve the white of the paper to emphasize the white color. Avoid coloring too heavily.

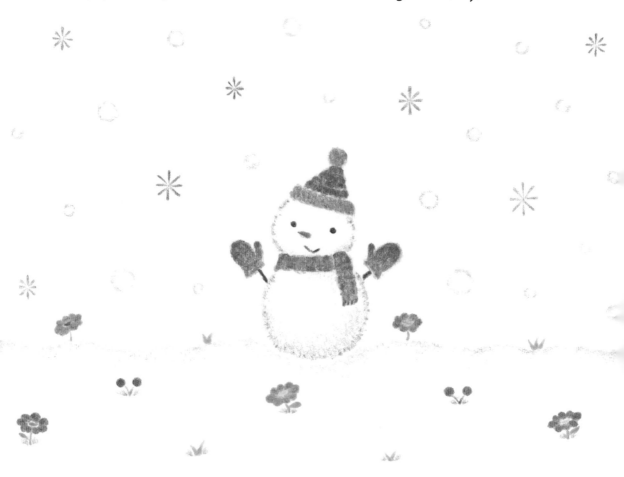

When using colored pencils to depict white objects, try lightly shading the areas that form the outline and shadows. To achieve the softness of snow, it's important to create the outline with a series of dots and short strokes rather than solid lines.

VIDEO Access the how-to video by typing the following URL into your web browser:

www.tuttlepublishing.com/
colored-pencil-drawings-and-doodles

For support, email us at
info@tuttlepublishing.com

COLORS

Light Blue · Pink · Orange · Black

Blue · Purple · Red · Brown

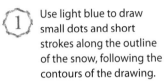

(1) Use light blue to draw small dots and short strokes along the outline of the snow, following the contours of the drawing.

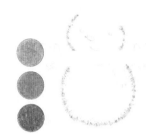

(2) Randomly layer blue, pink, and purple over the snowman using small, light strokes.

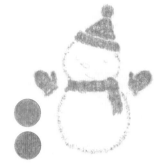

(3) Use orange and pink to color the gloves, scarf and hat, applying them with small circles to create a fluffy texture.

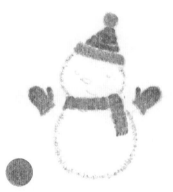

(4) Carefully layer red to create the pattern of the yarn on the scarf.

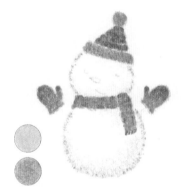

(5) Use light blue and blue to lightly shade the snowman to make it appear three-dimensional.

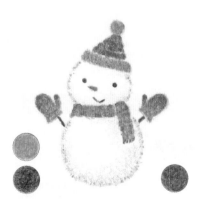

(6) Draw the carrot nose with orange, the eyes and mouth with black, and the stick arms with brown.

SKETCH

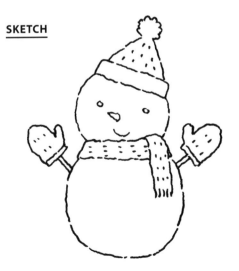

Try Drawing the Colors of Winter

On a snowy Christmas Eve, Santa Claus arrives carrying many presents.
It promises to be a magical night with the star of Bethlehem
shining particularly brightly. Let's use the festive decorations and
candles of Christmas to vividly decorate the shimmering scene.

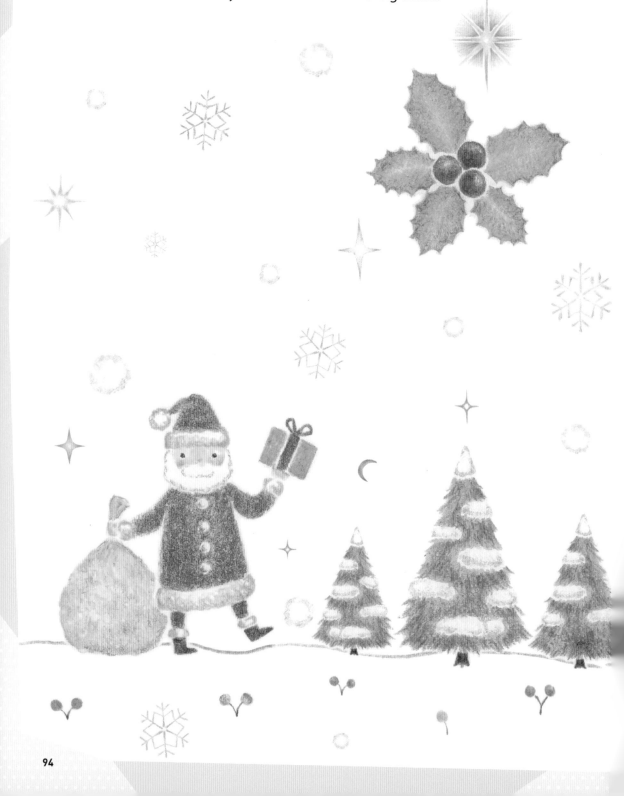

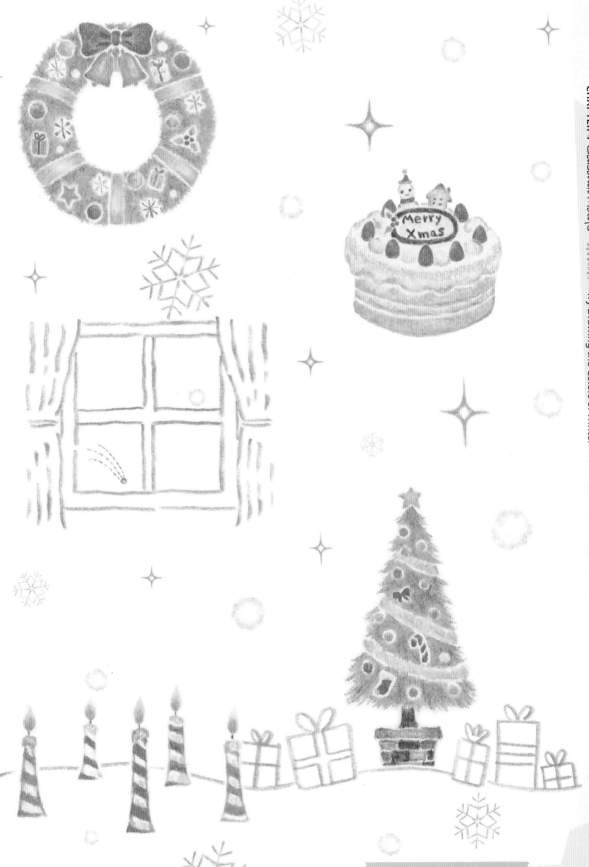

Merry Xmas

BEST TECHNIQUES

Candle
Layer yellow and orange gently for the flame.

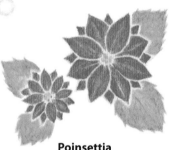

Wreath
Change colors as much as possible for the decorations. Draw the decorations first and then fill the wreath with green, filling in the gaps.

Christmas Cake
Lightly outline the frosting with pale orange and pink.

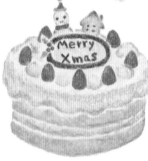

Clematis
Draw thin outlines with light green and light blue, layering colors where the tips and petals overlap.

Poinsettia
Leave a white outline to distinguish the overlapping "petals."

Holly
After drawing the berries and leaves, add blue to the leaf tips to create a cool color blend.

Christmas Tree
Start by drawing the decorations, and then color the fir tree green, depicting the needles as flowing downward.

Snow-Covered Fir Tree
Layer green with blue and purple for a shaded bough appearance. Add a touch of light blue for the snow.

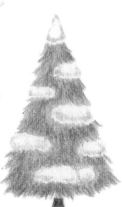

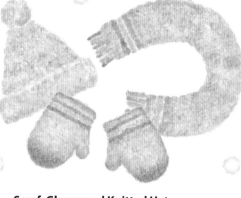

Scarf, Gloves and Knitted Hat
Use colors like orange and light green to draw small circles, creating a knit texture. For a finishing touch, add a multicolor smattering of dots.

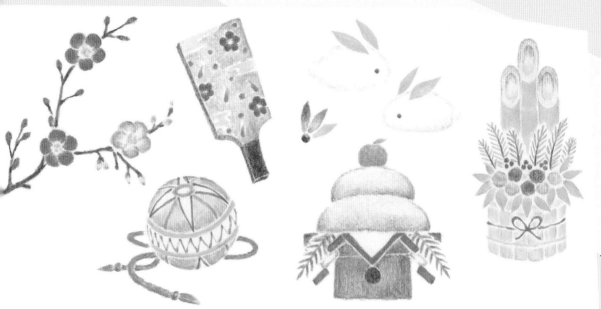

Plum Blossom
For white plum blossoms, layer pale orange and pink. Add shades of pink and red to the branches.

Temari Ball
Sharpen your colored pencils and draw the cord pattern with a consistent thickness.

Battledore (*Hagoita*)
Draw the board as straight as possible to avoid distorted lines. Small motifs appear more vivid with darker colors.

Rice Cakes (*Kagami Mochi*)
Color the edges with pale orange and leave the inside as white as possible.

Sacred Shinto Rope (*Shimenawa*)
Color the bamboo with light green, and then add vertical strokes of light blue, following the flow.

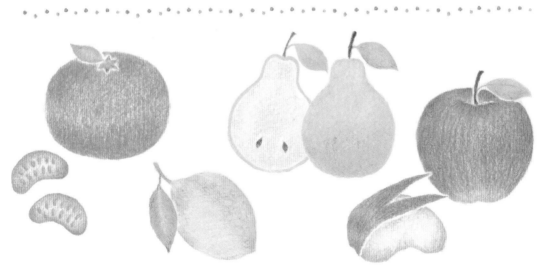

Mandarin Orange
Apply yellow and orange, and then gently layer light green and pink.

Lemon
Lightly color it yellow, and then add a subtle layer of light green all over. Add orange gradually to the fruit ends and shadows.

Bartlett Pear
Start with pale orange, and then layer yellow, light green and brown lightly while varying the colors.

Apple
Before coloring it red, layer yellow, pink and light green, following a vertical flow. Use an eraser to gently remove color to create a soft highlight.

Color the Seasons with Spot Illustrations

You can decorate with small motifs without having
to create full scenes or complex illustrations.

By arranging motifs like flower petals, stars
and fluffy cotton-ball-like elements, you can
create a bright and cheerful look.

Simple motifs such as cherry blossoms, fallen
leaves, and snowflakes can easily convey a
sense of the season and result in a light and
unpretentious finish.

CHAPTER 5

Combining Elements

In this chapter, I will explain advanced techniques by showing you
how to combine the motifs you've drawn so far, add backgrounds
and work with larger compositions. As you become more
comfortable with colored pencils, focus on creating
larger compositions that fill predetermined spaces.

Draw Combinations of Flowers and Plants

Flowers and Ivy

Let's arrange your favorite flowers and colors. While the look of the flowers themselves is important, the overall impression they make can change based on the shape and arrangement of the stems and leaves.

Decorating lettering goes hand-in-hand with floral embellishment. You can arrange the flowers not only in rings but also into squares or linear flourishes. Incorporating plants appropriate to the season referenced in the accompanying message makes it even more fun.

VIDEO Access the how-to video by typing the following URL into your web browser:

**www.tuttlepublishing.com/
colored-pencil-drawings-and-doodles**

For support, email us at
info@tuttlepublishing.com

COLORS

- Orange
- Brown
- Light Blue
- Red
- Yellow-Green
- Pale Orange
- Pink
- Blue
- Green

INSTRUCTIONS

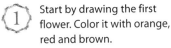

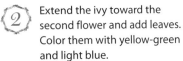

① Start by drawing the first flower. Color it with orange, red and brown.

② Extend the ivy toward the second flower and add leaves. Color them with yellow-green and light blue.

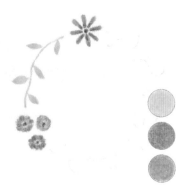

③ Draw in flowers with different shapes and colors from the first one. Color them with pale orange, pink and orange.

④ With a different color scheme than the first length of ivy, draw another length of ivy leading toward the third flower. Color it with yellow-green, brown and green.

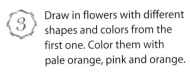

SKETCH

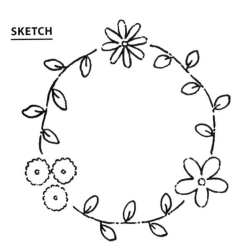

⑤ Draw the third flower, and connect the ring of motifs with a third length of ivy. Color the flower with hues such as pale orange, light blue, blue and pink, and color the ivy with yellow-green, green and blue.

101

Draw Combinations of Flowers and Plants

A Small Bouquet

Combining three flowers makes it easy to create a harmonious and manageable illustration. Try drawing them in your favorite colors.

Start with a few flowers and gradually increase the number, progressing from small clutch bouquets to larger ones. For a natural-looking bouquet, add in some greenery.

VIDEO Access the how-to video by typing the following URL into your web browser:

▶ **www.tuttlepublishing.com/colored-pencil-drawings-and-doodles**

For support, email us at **info@tuttlepublishing.com**

COLORS

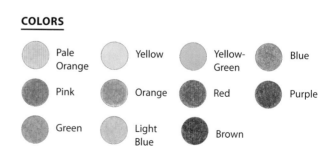

Pale Orange Yellow Yellow-Green Blue

Pink Orange Red Purple

Green Light Blue Brown

INSTRUCTIONS

1 Start by drawing the first flower. Gradually vary the intensity of the petals. Layer pale orange and pink.

2 Changing the color in the center of the flower can provide variety between similar-looking flowers. Use yellow, orange and yellow-green.

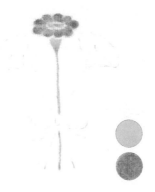

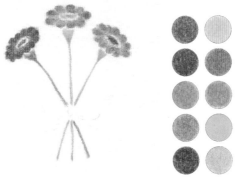

3 Extend the stem with yellow-green. Leave a slight gap at the ribbon's knot and then continue the stem. Add a hint of pink to the stem.

4 Draw the second and third flowers. You can change the angles and heights of the flowers as you like.
Left: Petals in pink and red. Center in blue and purple. Stems in green and blue.
Right: Petals in pale orange, pink and orange. Center in orange, brown, yellow-green, etc. Stems in yellow-green and light blue.

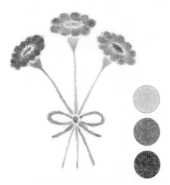

SKETCH

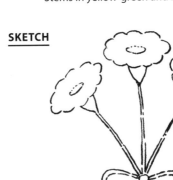

5 Carefully layer the ribbon with pink. Overlap with pale orange, pink and brown. Finally, adjust the length of the 3 stems to finish.

Try Drawing Compositions Filled with Flowers

Combine the flowers and plants you've drawn
so far to create your own bouquet, like a florist.

Single stem

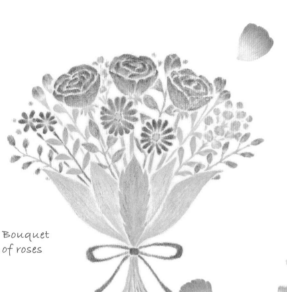

Bouquet of roses

Wildflower Arch
Changing the colors and shapes
of flowers and ivy can create a
complex impression for the arch.

Rose Bouquet
With a pink-colored base, create variations in
the flowers by layering different amounts of
colors like pale orange, yellow and orange.

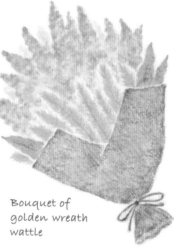

Bouquet of golden wreath wattle

Golden Wreath Wattle Bouquet
The fluffy outline of the clustered blossoms
is drawn by layering many small circles.

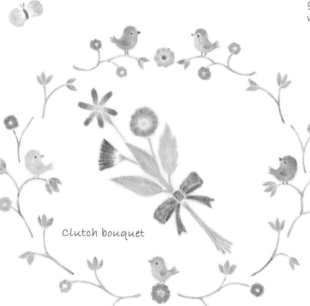

Clutch bouquet

Bird Wreath
Arrange the adjacent birds and
flowers in different colors to create
a colorful impression.

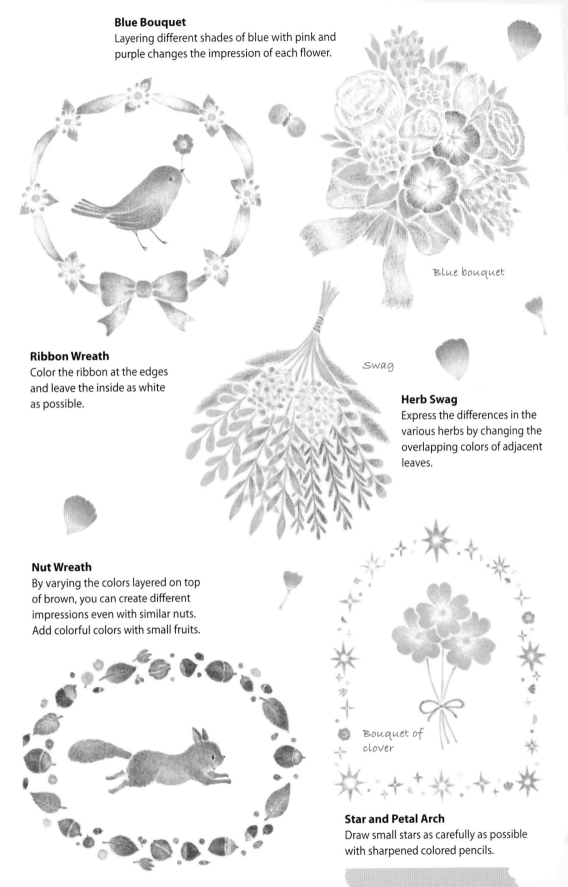

Blue Bouquet
Layering different shades of blue with pink and purple changes the impression of each flower.

Blue bouquet

Ribbon Wreath
Color the ribbon at the edges and leave the inside as white as possible.

Swag

Herb Swag
Express the differences in the various herbs by changing the overlapping colors of adjacent leaves.

Nut Wreath
By varying the colors layered on top of brown, you can create different impressions even with similar nuts. Add colorful colors with small fruits.

Bouquet of clover

Star and Petal Arch
Draw small stars as carefully as possible with sharpened colored pencils.

Color a Picture-book-like Scene

Illustrations with the Ground Included

Start by drawing everything but the ground, and then add the ground under and behind what you've already drawn.

By simply adding a bit of ground to motifs like animals, you can bring depth and hints of an unspoken story to your illustrations. Have fun combining different ground settings, like meadows or flower fields.

VIDEO Access the how-to video by typing the following URL into your web browser:

www.tuttlepublishing.com/colored-pencil-drawings-and-doodles

For support, email us at **info@tuttlepublishing.com**

COLORS

○ Various Flower Colors

○ Yellow-Green

○ Green

○ Yellow

○ Pink

○ Pale Orange

○ Brown

INSTRUCTIONS

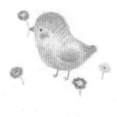 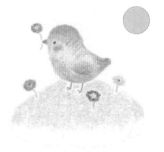 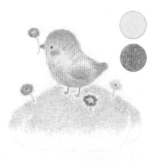

① Draw various colored flowers on the ground.

② Use yellow-green to color the upper half of the ground while avoiding the flowers and chicks.

③ Gently layer yellow and pink over the color set down in step 2.

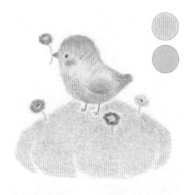 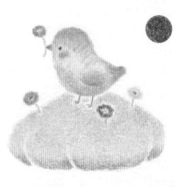

④ Add pale orange on the lower half of the ground. Blend the boundary between yellow-green and pale orange with a thin layer of yellow-green.

⑤ Apply a small amount of brown to the bottom of the area colored in step 4.

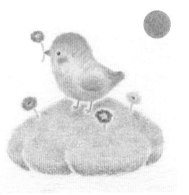

SKETCH

⑥ Use green to add shadows to the chick's feet. By adding green to the shadows of the ground's protrusions, you'll create the appearance of an island and add depth to the illustration.

Color a Picture-book-like Scene

Illustrations with a Background

To create soft textures, start by gently layering various colors, and avoid oversaturation.

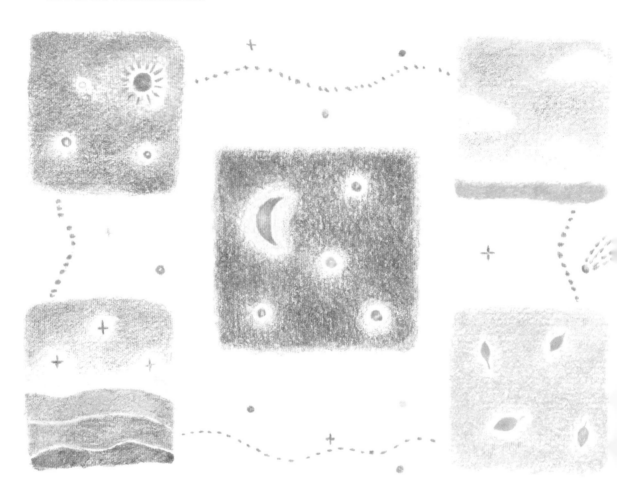

Imagine the illustrations above as small windows into different landscapes. Try drawing various backgrounds showing different times and places. You'll soon be able to smoothly finish large areas without unevenness.

VIDEO Access the how-to video by typing the following URL into your web browser:

▶ www.tuttlepublishing.com/
colored-pencil-drawings-and-doodles

For support, email us at
info@tuttlepublishing.com

COLORS

○ Yellow ● Blue

○ Light Blue ● Purple

INSTRUCTIONS

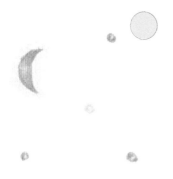

① Lightly apply yellow around the moon.

② Use light blue to color while avoiding the moon and stars, being careful not to overlap with the yellow from step 1. Having adequate space around motifs makes it easier to color.

③ Layer blue over the color added in step 2. Add the color gradually.

④ Lightly layer purple in some areas.

SKETCH

⑤ Layer light blue and blue over the entire illustration to blend the colors. If it becomes too dark, use an eraser to gently remove some color and adjust the overall tone.

Try Drawing a Picture-book-like Scene

Here are a few illustrations with seasonal backgrounds and ground.
Have fun trying various combinations.

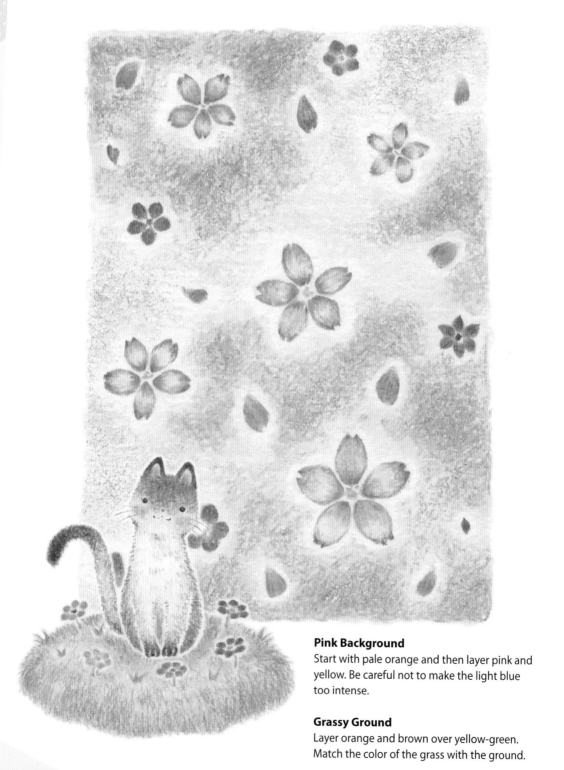

Pink Background
Start with pale orange and then layer pink and yellow. Be careful not to make the light blue too intense.

Grassy Ground
Layer orange and brown over yellow-green. Match the color of the grass with the ground.

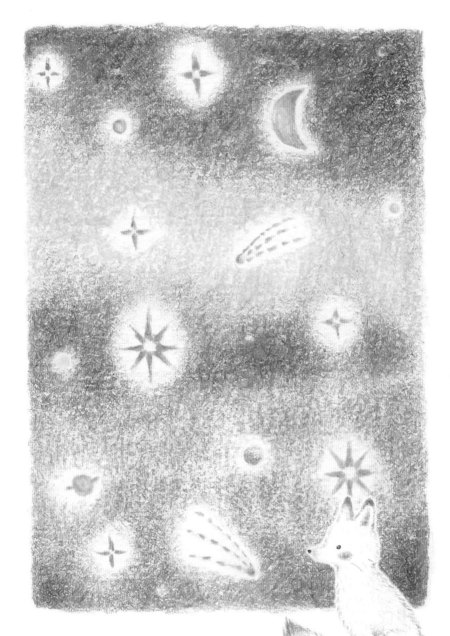

Blue Background

After determining the areas for yellow-green and pink, avoid overlapping with the blue part. Lightly layer light blue at the boundaries.

Snowy Ground

Use blue and light blue to create a border around the ground with dot-like strokes. Add shadows in blue to the indentations in the snow.

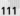

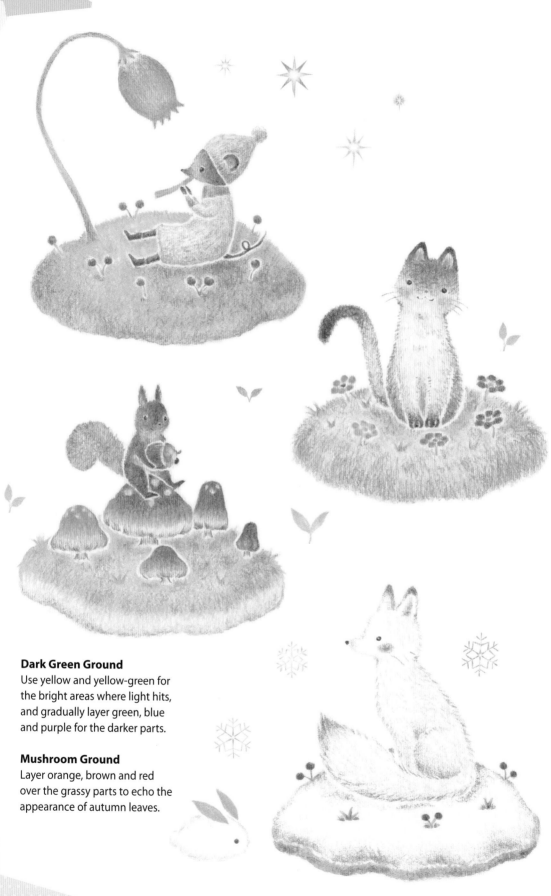

Dark Green Ground
Use yellow and yellow-green for the bright areas where light hits, and gradually layer green, blue and purple for the darker parts.

Mushroom Ground
Layer orange, brown and red over the grassy parts to echo the appearance of autumn leaves.

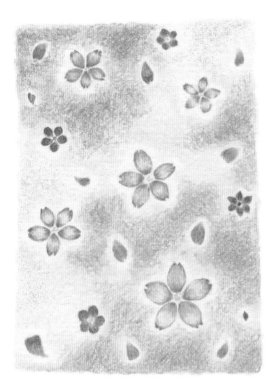

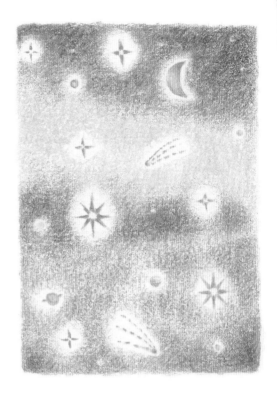

Green Background
Randomly deposit light yellow to create a natural look, like dappled sunlight filtering through leaves.

Yellow Background
Layer more orange and pink toward the bottom, and use more yellow and pale orange as you go upward.

Level-up Your Toolkit

Once you get used to the 12 colored pencils used in this book, you will probably want to increase the number of colors you use, or try other brands of colored pencils that are sold online or in artists' supply stores.

Professional-grade colored pencils can be found not only in artists' supply stores and online shops but also in stationery stores and large general merchandise stores that offer a wide range of art supplies. There are various manufacturers to choose between, and while pencil-set purchases are cost-effective, you can also buy individual pencils. Try different brands to find the one that suits you best.

I use Japanese-made, oil-based Karismacolor brand pencils in much of my work. Among oil-based colored pencils, Karismacolor pencils have a particularly soft core. This makes them well-suited for applying color with gentle pressure, making layering a snap. For artists without access to Karismacolor pencils, comparable Prismacolor pencils are available. Both brands offer pencils in 150 different colors.

KARISMA-COLOR · Bleu Paon · PC1027 · Peacock Blue

☀ The appeal of working with colored pencils

Colored pencil pigment becomes saturated and more vibrant as you layer it, making it easy to create soft and nuanced expressions using the medium. Having a wide range of available colors—including subtle pale shades and bright vivid hues, which are difficult to achieve through layering—allows for the creation of rich and expressive illustrations.

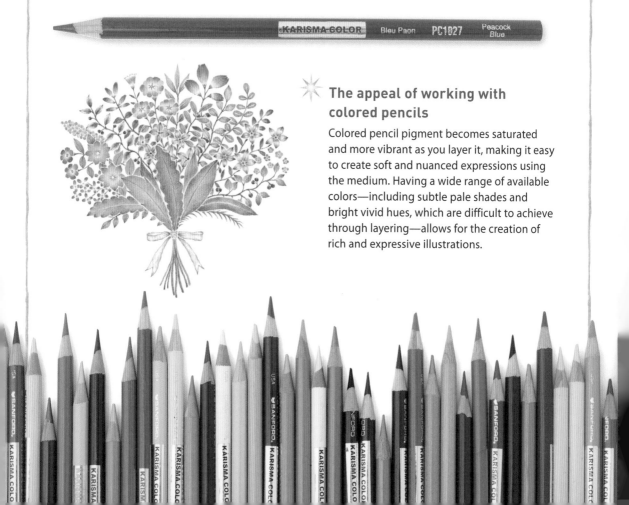

CHAPTER 6

Original Illustrations and Crafts

The drawing lessons of the previous chapters are now concluded. In this chapter, you'll take your knowledge of colored pencil drawing a step further and not only follow the example illustrations but also create your own original artwork. Additionally, you'll learn how easy it is to turn your illustrations into greeting cards or frame them to decorate your living space. Enjoy sharing your artwork with others!

Draw Your Own Unique Illustrations

In this book, we've gone through lessons on using colored pencils with provided templates. Here, as the next step, I'll introduce some key points for creating your own original illustrations and finding the motifs you'd like to draw.

🌱 Finding the Motifs You Want to Draw

To find motifs, try drawing small items from your surroundings, or look for inspiration in photos, magazines and more. Start by sketching with a pencil and refine your drawing before adding details with colored pencils.

🌱 Sketching with a Pencil

Observe your subject and create a sketch with a pencil. For your second sketch, simplify the lines of finer details like petals and leaves. On the third sketch, streamline the lines further, emphasizing the features you want while eliminating unnecessary elements.

1.　　　　　2.　　　　　3.　　　　COMPLETE!

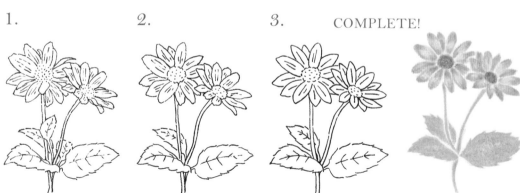

☙ Adding Color

Coloring Objects with Curves

Begin with light colors and slowly draw along the outline. Pay attention to the areas where light hits, and use different shades to create depth. Maintain a certain level of stylized flatness in your coloring to avoid making it too realistic.

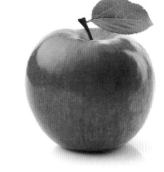

1.

2.

3.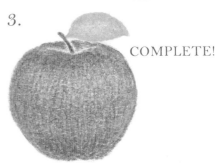

COMPLETE!

Representing Transparency

With a gentle touch, trace the outline of the teapot, and add variations to the lines for the thicker parts of the glass. For the tea, keep the middle part light and add darker tones with multiple subtle layers. To convey transparency, it's important not to overdo the coloring.

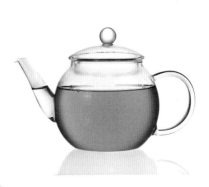

2.

1.

3.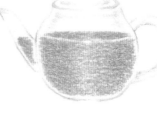

COMPLETE!

✗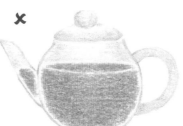

Mistakes in Coloring the Teapot

If you color the entire teapot with too much blue and render the tea uniformly, it will diminish the impression of transparency when light shines through.

Colored Pencil Craft Ideas to Color Daily Life

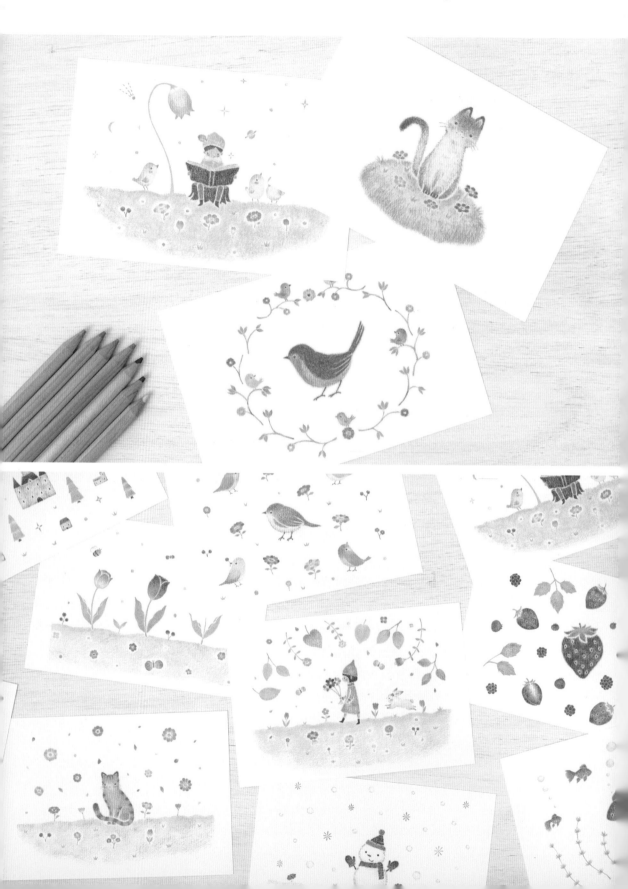

Turning Illustrations into Postcards

It would be a shame to let your illustrations remain hidden away in your sketchbook. If you have a postcard-sized sketchbook, you can use the pages as postcards directly without having to do any trimming.

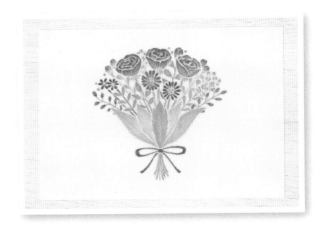

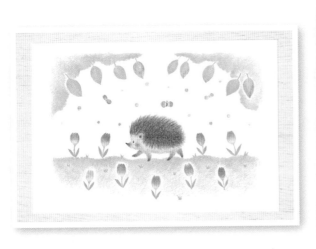

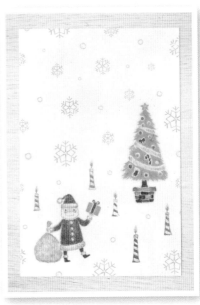

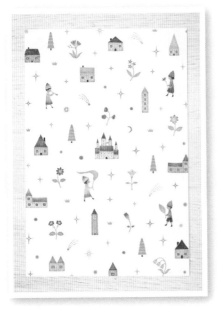

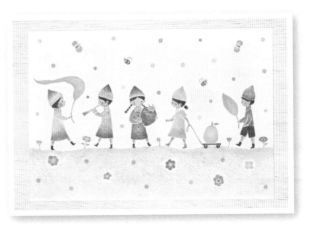

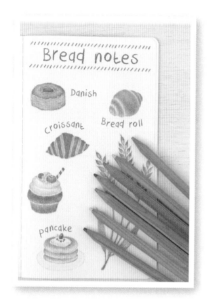

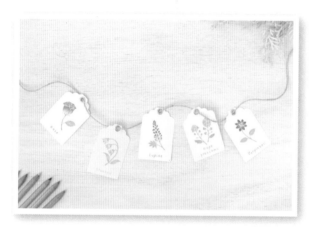

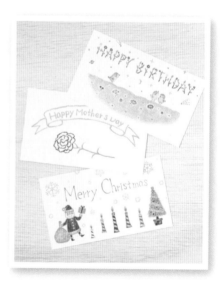

Incorporate Illustrations into Your Daily Life

Add your original illustrations to memos, note cards or gift tags, integrating the art into the facets of your everyday life.

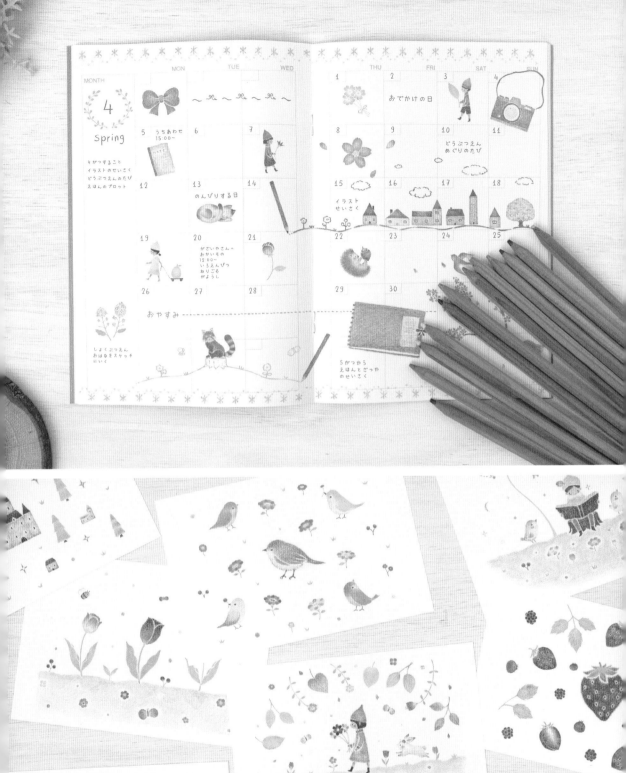

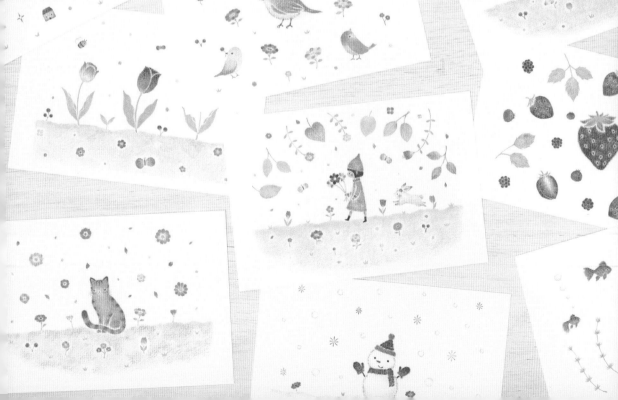

Improve Your Drawings with Professional-grade Art Materials

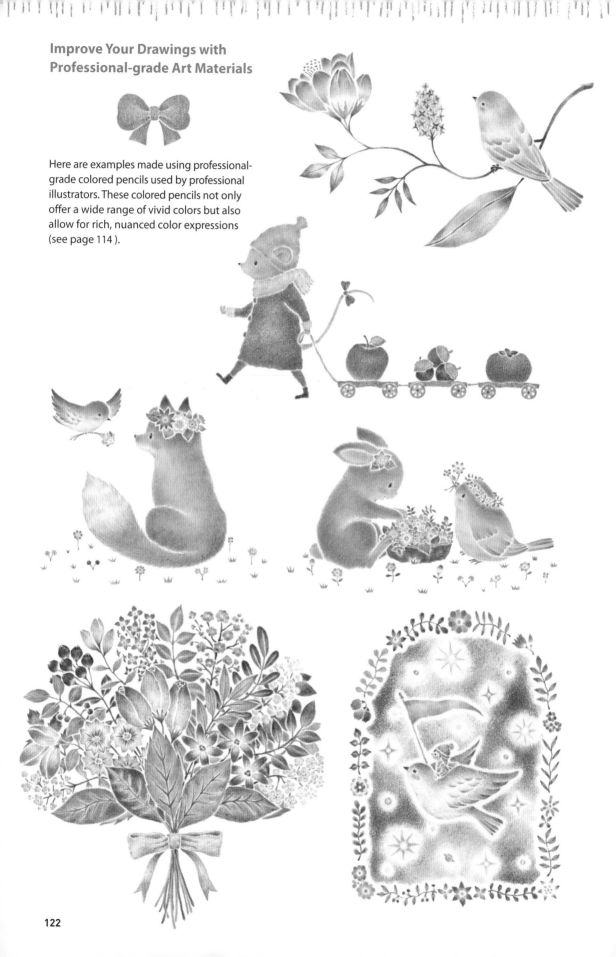

Here are examples made using professional-grade colored pencils used by professional illustrators. These colored pencils not only offer a wide range of vivid colors but also allow for rich, nuanced color expressions (see page 114).

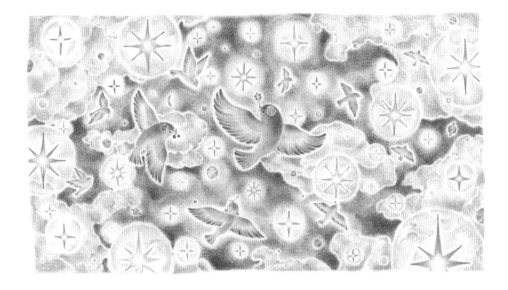

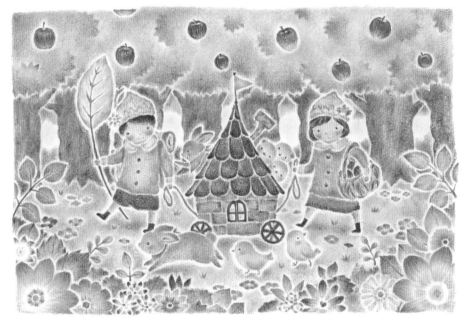

How to Write Cute Letters

You can decorate greeting cards with adorable colored pencil embellishments and handwritten text. By drawing a colorful hand-written message, your card will become all the more heartfelt.

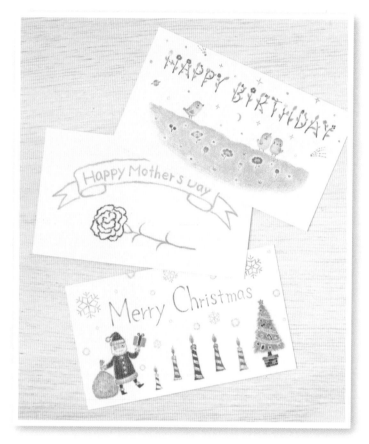

When writing text, it's a good idea to start with a pencil draft and then proceed to carefully add color. Rather than simply writing the letters, it's better to trace the shapes of the letters, fleshing them out gradually. Try embellishing your text with flowers, creating gradients within single characters and experimenting with various creative ideas.

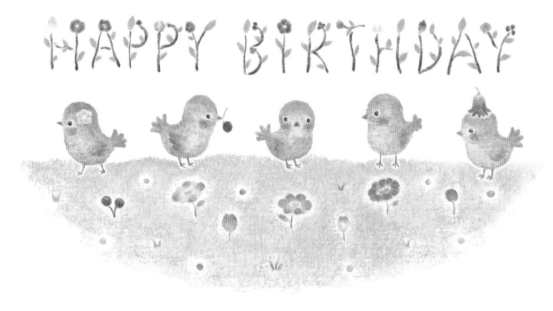

HAPPY BIRTHDAY

for you

for you

THANK YOU

THANK YOU

HAPPY

Welcome

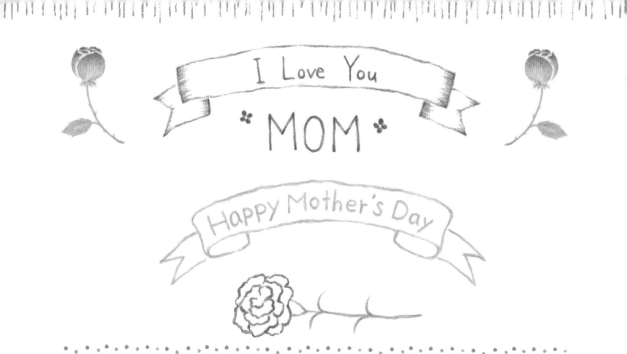

I Love You
* MOM *

Happy Mother's Day

Thank you Father

Book

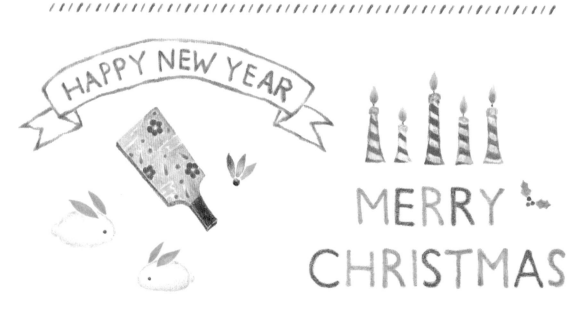

HAPPY NEW YEAR

MERRY
CHRISTMAS

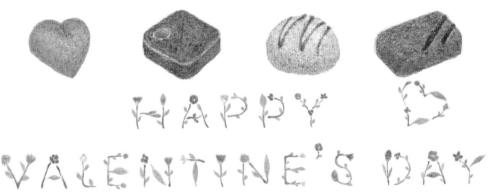

Books to Span the East and West

Tuttle Publishing was founded in 1832 in the small New England town of Rutland, Vermont [USA]. Our core values remain as strong today as they were then—to publish best-in-class books which bring people together one page at a time. In 1948, we established a publishing outpost in Japan—and Tuttle is now a leader in publishing English-language books about the arts, languages and cultures of Asia. The world has become a much smaller place today and Asia's economic and cultural influence has grown. Yet the need for meaningful dialogue and information about this diverse region has never been greater. Over the past seven decades, Tuttle has published thousands of books on subjects ranging from martial arts and paper crafts to language learning and literature—and our talented authors, illustrators, designers and photographers have won many prestigious awards. We welcome you to explore the wealth of information available on Asia at **www.tuttlepublishing.com.**

Published by Tuttle Publishing, an imprint of Periplus Editions (HK) Ltd.

www.tuttlepublishing.com

ISBN 978-4-8053-1795-2

12 Shoku no Iroenpitsu de Egaku Chiisana Illust Tenaraicho
Copyright © 2021 Atelier RiLi
English translation rights arranged with Impress Corporation through Japan UNI Agency, Inc., Tokyo

Printed in China 2405EP
28 27 26 25 24 10 9 8 7 6 5 4 3 2 1

Atelier RiLi is a Japanese illustrator who focuses on picture book illustration and other freelance illustration work. She has illustrated many books, and her artwork has appeared in advertisements, and has been exhibited in solo exhibits, group exhibits and other special events in Japan. Her creative activities aim to create picture books and illustrations that add a little warmth to daily life. https://www.atelierrili.com.

Distributed by:

North America, Latin America & Europe
Tuttle Publishing
364 Innovation Drive
North Clarendon; VT 05759-9436 U.S.A.
Tel: (802) 773-8930; Fax: (802) 773-6993
info@tuttlepublishing.com; www.tuttlepublishing.com

Japan
Tuttle Publishing
Yaekari Building 3rd Floor
5-4-12 Osaki Shinagawa-ku; Tokyo 141 0032
Tel: (81) 3 5437-0171; Fax: (81) 3 5437-0755
sales@tuttle.co.jp; www.tuttle.co.jp

Asia Pacific
Berkeley Books Pte. Ltd.
3 Kallang Sector, #04-01; Singapore 349278
Tel: (65) 6741-2178; Fax: (65) 6741-2179
inquiries@periplus.com.sg; www.tuttlepublishing.com

TUTTLE PUBLISHING® is a registered trademark of Tuttle Publishing, a division of Periplus Editions (HK) Ltd.

How to access the how-to videos and printable PDFs

1. Make sure you have an Internet connection.
2. Type the URL below into your web browser.

www.tuttlepublishing.com/
colored-pencil-drawings-and-doodles

For support, you can email us at **info@tuttlepublishing.com**